How To Photograph

Reptiles &
Amphibians

How To Photograph

Reptiles & Amphibians

Larry West
and William P. Leonard

STACKPOLE
BOOKS

Published by
STACKPOLE BOOKS
5067 Ritter Road
Mechanicsburg, PA 17055

Printed in Hong Kong

10 9 8 7 6 5 4 3 2 1

First edition

Cover design by Wendy Reynolds

Library of Congress Cataloging-in-Publication Data

West, Larry.
 How to photograph reptiles and amphibians/Larry West and
 William Leonard.
 p. cm.—(How to photograph)
 ISBN 0-8117-2454-9 (pbk.)
 1. Photography of reptiles. 2. Photography of amphibians.
3. Nature photography. I. Leonard, William 1953- . II. Title
III. Series
TR729. R47W47 1997
778.9'3279—DC21
 96-53009
 CIP

We dedicate this book to our families—Bonnie, Jeff, and Jennifer West and Vicki, Nick, and Megan Leonard—and to the many people who have dedicated their lives to the preservation of biodiversity.

CONTENTS

ACKNOWLEDGMENTS

Many people contributed to this book. First and foremost, we thank our families. They endured many hours alone tending to life's routine chores while we were out making photographs or at home distracted by an unfinished manuscript.

We are grateful to Dick Bartlett, Jim Harding, and Klaus Richter for reading and providing valuable comments on an earlier draft of the manuscript. We also thank Mike Rigsby for both his expert editorial assistance and his companionship in the field.

Many biologists generously shared their time and knowledge, and provided field assistance. Without them, this book might never have been possible. We would especially like to thank Dave Clayton, Lowell Diller, Lisa Hallock, Jim Harding, Karin Hoff, Larry Jones, Vicki Leonard, Amy Lind, Kelly McAllister, Bob Storm, Hart Welsh, and Al Wilson.

PREFACE

The primary emphasis of this book is on techniques for photographing amphibians and reptiles in nature. This approach reflects our personal interests and biases. These same techniques work equally well for those who prefer to photograph these animals in captive situations such as zoos, research settings, or home terrariums. But we urge all our readers to spend at least some time in the field observing and recording the lives of these and other animals in their native environment.

Although reptiles and amphibians are quite different, scientists have traditionally lumped them together in a branch of science called *herpetology*. And as a group, the animals themselves are commonly called *herps*, from the Greek word for creeping thing. Herps, of course, do much more than just creep: they hop, leap, run, swim, climb, dive, and glide. But for those who study herps—whether they be professional herpetologists or dedicated amateur herpers—the name has stuck.

The efforts of herpetologists and herpers alike have added greatly to our knowledge of these animals, but there's still much we don't know. For many species, we don't even have basic life history information such as distribution, home ranges, breeding and feeding behaviors, and predator-prey relationships. Through their observations and images, photographers who spend time in the field with herps can add to our understanding and appreciation of these animals.

In recent years, there has been considerable discussion about declining amphibian populations around the world. The northern leopard frog (*Rana pipiens*), for example, has experienced dramatic declines across the United States and Canada. And both the golden toad (*Bufo periglenes*) of Costa Rica and the stomach-brooding frog (*Rheobatrachus silus*) of Australia are now feared extinct. Explanations for the worldwide amphibian decline are many, but most involve some human-caused environmental change. Topping the list of possible explanations are the destruction of wetlands and upland habitats by development; chemical pollution; increases in ultraviolet light, resulting from the thinning of the atmospheric ozone layer; and the acidification of lakes, streams, and wetlands from coal-burning power plants and automobile emissions.

Although amphibians get most of the press, many reptiles are also in jeopardy. Formerly common North American species such as the wood turtle (*Clemmys insculpta*), the racer (*Coluber constrictor*), and the timber rattlesnake (*Crotalus horridus*) have dis-

appeared from much of their former ranges. Even garter snakes are becoming scarce in many areas. Habitat destruction is a major problem, as is commercial exploitation of some species for the pet trade.

As naturalists and nature photographers, we must recognize that even our actions can have a detrimental effect on the very wildlife and habitats we cherish. We have a responsibility to ensure that our efforts to observe and photograph wild creatures do not degrade sensitive plant communities or threaten the well-being of the animals living there. Throughout this book, we emphasize an approach that minimizes disturbance to both the animals and the environment.

The Equipment

Cameras

Rapidly evolving technology has given photographers many choices when shopping for this essential piece of equipment. Cameras can now do more than was imagined even 20 years ago. Consequently, the range of choices may seem overwhelming. You can simplify the decision by keeping your subject matter in mind. When you narrow your use to nature photography, and then further to amphibian and reptile photography, your equipment-buying decisions become much simpler.

Still, your decision should not be made lightly. Investing in a camera system is a long-term proposition for most people. Once you choose a given system, especially the optics, switching to a different format or manufacturer is expensive. Understanding the technological choices available will help you choose the system that's right for you and your photographic habits.

How a Camera Works

Virtually all camera and lens systems use six basic components that work together with the film and the photographer to create photographs. Those components are the camera body, the shutter, the viewfinder, the lens, the aperture, and the focus mechanism.

The *camera body* is lighttight and comes in many sizes or formats. Depending on the camera type, the body may house many components. Most importantly, it houses the film plane, which holds the film flat and in place at exactly the correct distance from the lens to record an image. When we talk about camera formats, we are referring to the film size. For instance, a 35mm camera uses roll film that is exposed in segments 35mm wide.

The *shutter* mechanism is a mechanical curtain, or blade arrangement, that opens and closes to allow light (reflected from the subject) to travel through the lens and aperture to the film. The speed of the shutter's opening and closing (1/15, 1/30, 1/60, 1/125, 1/250 of a second) controls the amount of time that the film is exposed to light.

The *viewfinder* enables the photographer to see the image being photographed. Camera types are usually discussed in terms of their viewing or focusing systems. For instance, single lens reflex (SLR) refers to the mirror and hinge system that allows the photographer to see the image right up to the moment of exposure, through the same lens used to make the photograph.

The *lens*, traditionally made of glass, is the camera's eye, allowing light to carry the outside image to the film plane.

The *aperture*, or diaphragm, also works to control the amount of light that reaches the film by enlarging or reducing the opening

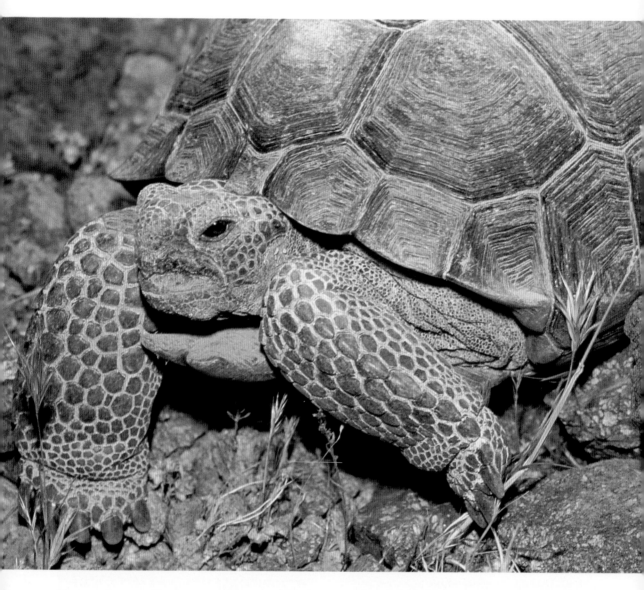

Desert tortoise *(Gopherus agassizii)* basking in the desert sun. *105mm macro lens, TTL electronic flash, camera compensation dial set at +0.3, 50-speed film, 1/250 second, f/11, handheld.*
This tortoise was found beside the entrance to its burrow on a rocky Nevada hillside. Fill flash was used to put a highlight in its eye.

through which light passes. The size of the aperture (f/4, f/5.6, f/11, f/22, and so on) also controls the depth of field, or how much of the photograph is in sharp focus.

The *focusing mechanism* moves certain lens elements closer to or farther from the film to focus the images of subjects at various distances.

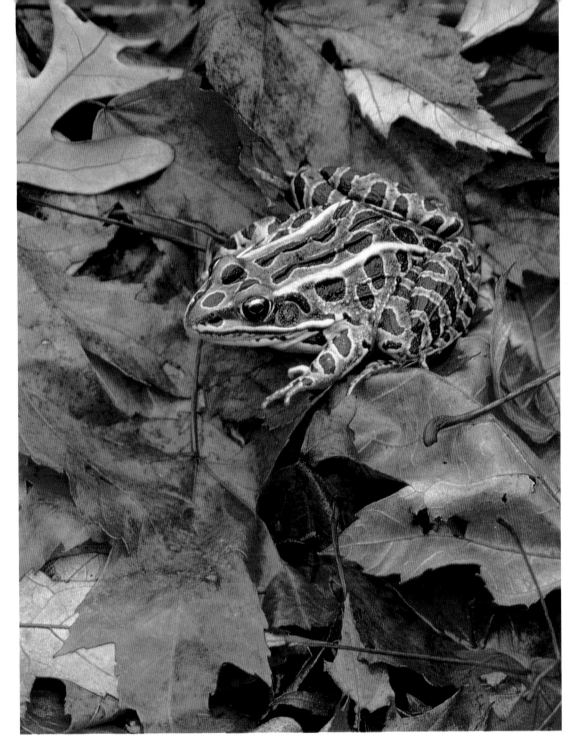

Northern leopard frog *(Rana pipiens)* on late autumn leaves. *105mm macro lens, 25-speed film, 1 second, f/16, on tripod.*

On a warm autumn day, a northern leopard frog crosses a small woodland on the way to an overwintering pond.

To make a photograph, the photographer loads the proper film, attaches the proper lens, selects the appropriate aperture size and shutter speed, focuses and composes the image through the viewfinder, and then trips the shutter. Light reflected from the subject is focused on the film, where it causes a chemical reaction on the light-sensitive emulsion. The film is then ready for a processor to transform it into a permanent photographic image.

The Best Camera for Herp Photography

Over the years, wonderful nature photographs have been made using nearly every camera format. Today, most professional and amateur nature photographers use 35mm SLR systems. One reason is the great versatility of these systems. Even if you narrow your interests to just herps, your subjects may range from tadpoles to alligators. You may stalk rattlesnakes for hours or take close-ups of salamander eggs.

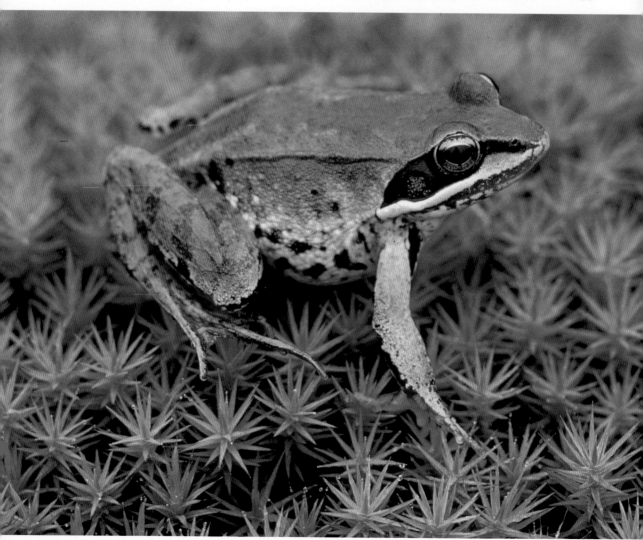

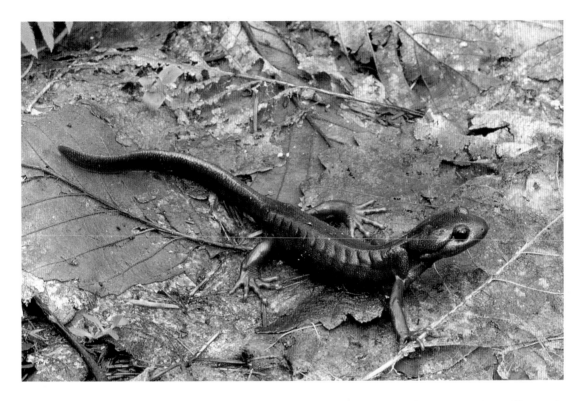

Northwestern salamander *(Ambystoma gracile)* on fallen leaves. *105mm macro lens, 50-speed film, 2 seconds, f/16, on tripod.*

This Northwestern salamander sat motionless on the forest floor, allowing the camera to be used on a tripod to achieve a long shutter speed and a small aperture for more depth of field.

To cover this range, you need the precise focus and compositional control that 35mm SLRs offer. You need a camera body that is small and light enough to allow some grace in field stalking yet is able to hold enough film so that you don't have to stop and reload after each exposure. You need a wide range of optics and types of film.

Wood frog *(Rana sylvatica)* on haircap moss. *105mm macro lens, 25-speed film, 1/2 second, f/16, on tripod.*

Walking across a lush carpet of moss in midsummer, a wood frog is easily recorded using existing light.

Because so many photographers use 35mm SLR cameras, the technologies developed for this format have vastly expanded the possibilities in field photography— beyond those of even 10 years ago. Most new cameras have computerized "brains" that can measure light, set the aperture and shutter speed, focus the image, track the subject, load and advance the film, record the date, trip the shutter, and tell you when you're low on power.

These electronic aids make photography a much more relaxing experience when you want it to be, but they won't guarantee that you'll get the photos you want unless you understand how they work and when it's

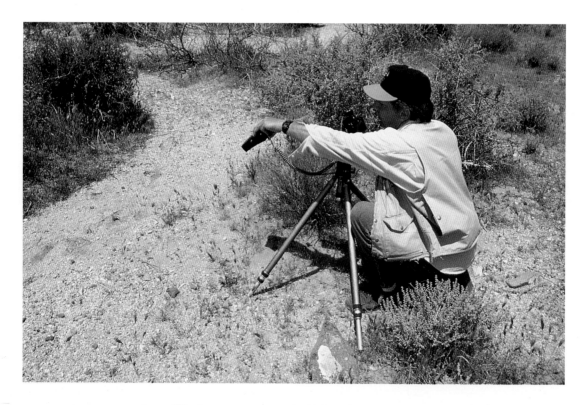

appropriate to use them. We do not recommend investing in a camera that will not allow manual override of the electronic wizardry. In the chapters ahead, we discuss when—and when not—to use these features.

Through-the-Lens Meter

A through-the-lens (TTL) meter is what its name implies—a meter that reads light through the lens to help you determine how to set the aperture and shutter speed to deliver the best exposure for your subject. Before these sophisticated systems were developed, most photographers used hand-held meters to measure the light, but in-camera systems are far superior for close-up work.

There are three main types of TTL metering: center-weighted, spot, and multisegment. Each reads light entering the lens and calculates an exposure based on certain built-in patterns and assumptions. Center-

Bill with zebra-tailed lizard *(Callisaurus draconoides)*.

Waiting for just the right pose, Bill relies on a tripod to hold his composition and eliminate camera movement.

weighted systems place more importance on light readings coming from the center of the area framed in the viewfinder. They bias their calculations to give greater importance—typically 60 to 90 percent—to this area of the image. A spot meter narrows this area of sensitivity to a very small circle in the center of the frame. It allows selective exposure readings from a portion of a subject (allowing you to place tonalities where you want them) while ignoring the surrounding field of view.

Multisegment meters measure and analyze the pattern of light reflecting from several areas of the image. From this information,

they attempt to calculate an exposure that will reproduce the principal subject most pleasingly. These computer-driven systems offer beginning photographers a better exposure balance among foreground, subject, and background. In many situations, multisegment meters can help even seasoned photographers manage difficult lighting situations. But, as with all the tools available to photographers, the better you understand the capabilities, limits, and biases of meters, the better chance you have of getting the exposures you want.

Most modern cameras also have a fourth meter that controls TTL flash exposure. The pattern read by these TTL flash meters varies among camera models.

Interchangeable Focusing Screens

When looking through a single lens reflex (SLR) camera, you see the image as it comes through the lens and reflects from the mirror

Singing Pacific treefrog *(Hyla regilla)*. *105mm macro lens, TTL electronic flash, camera compensation dial set at +0.7, 50-speed film, 1/250 second, f/11, handheld.*

Some nights, frogs won't tolerate any disturbance and stop singing whenever they sense your presence. On other nights—like the night this image was made—it seems that nothing can distract calling males from their mission of attracting females.

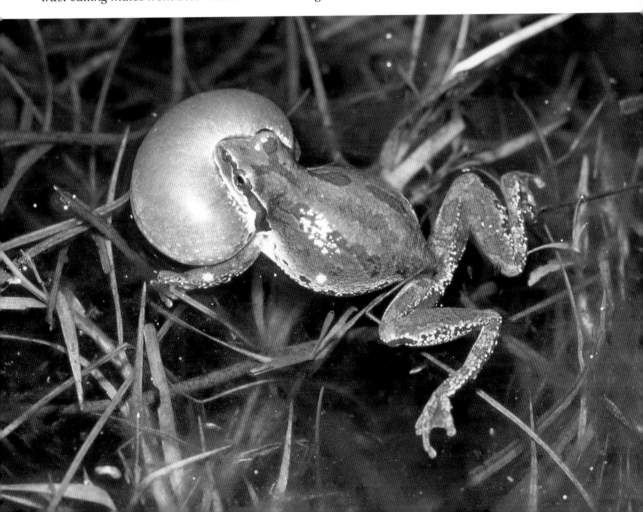

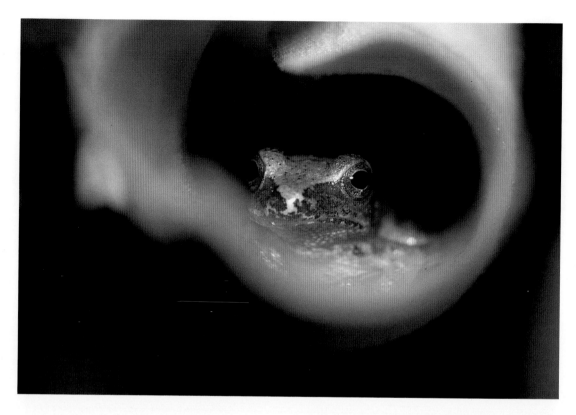

Spring peeper *(Pseudacris crucifer)* in curled milkweed leaf. *105mm macro lens, manual electronic flash, 25-speed film, 1/60 second, f/11–16, on tripod.*

In order to light the little frog inside the curled milkweed leaf, the camera was mounted on a tripod and the flash was held directly on the lens.

onto the focusing screen. The light then passes up through the roof prism, where it's turned right side up and right way around.

The screen helps the photographer achieve sharp focus and create a pleasing composition. On current camera models, the screen installed by the manufacturer will probably serve you well for everything from close-up to long telephoto work. But there are many other focusing patterns available that you might consider using. Some have grid lines that help you keep vertical lines vertical and horizontal lines horizontal when you compose images. Some allow more light to pass through to your eye, which can be critical when working up close in low light—as with much herp photography. If your focusing screen is more of a hindrance than a help, consider a bright matte screen, the sort that is standard in current auto-focus cameras.

Motor Drive

Most cameras today have some sort of self-contained motor drive. This feature is essential when photographing wildlife, because many behaviors can take place during the time it takes to wind a frame of film. Motor drives advance film at speeds from 3.3 to 8 frames per second. Many older cameras can also be fitted with add-on motor drive devices, but they are less prac-

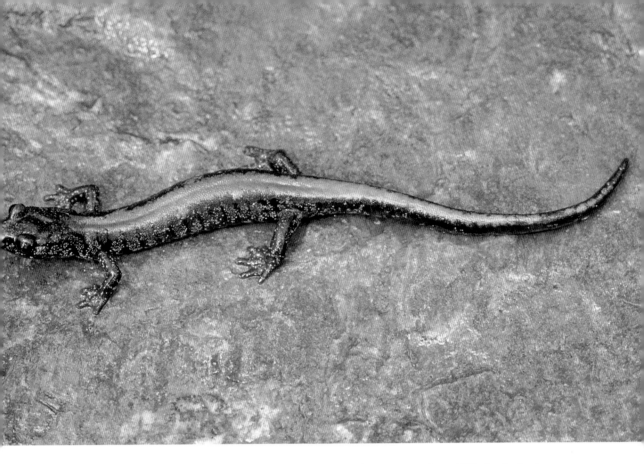

Coeur d'Alene salamander *(Plethodon idahoensis)*. *105mm macro lens, TTL flash, flash compensation dial set at -1.7, 50-speed film, 1 second, f/16, on tripod.*

Coeur d'Alene salamanders live in rocky seeps and along small streams in the forests of Idaho, Montana, and British Columbia. These aquatic microhabitats provide an abundance of small insect prey, and buffer the extremes of summer and winter temperatures and summer drought, allowing these salamanders to persist in the harsh northern Rocky Mountain climate. A fill flash was used here to add a little sparkle to the salamander and the rocky background in the overcast light.

tical because of the bulk and weight they add. The modern 35mm SLR camera bodies with their built-in, lightweight motor drives are far more user-friendly.

Exposure Compensation Dial
The exposure compensation dial allows you to fine-tune the exposure when your camera is in its automatic or program mode. This dial is also the proper way to control TTL flash exposures. Most newer cameras are equipped with this feature.

Mirror Brakes or Mirror Locks
When you trip the shutter, the mechanical movement of the lens closing to the correct aperture, the reflex mirror snapping up against the focusing screen, and the shutter bouncing open and shut cause internal movement that shakes the camera. This movement can be enough to degrade the image, particularly at certain shutter speeds.

On older cameras, the solution was a mirror-lock device that allowed you to lock the reflex mirror out of the light path before

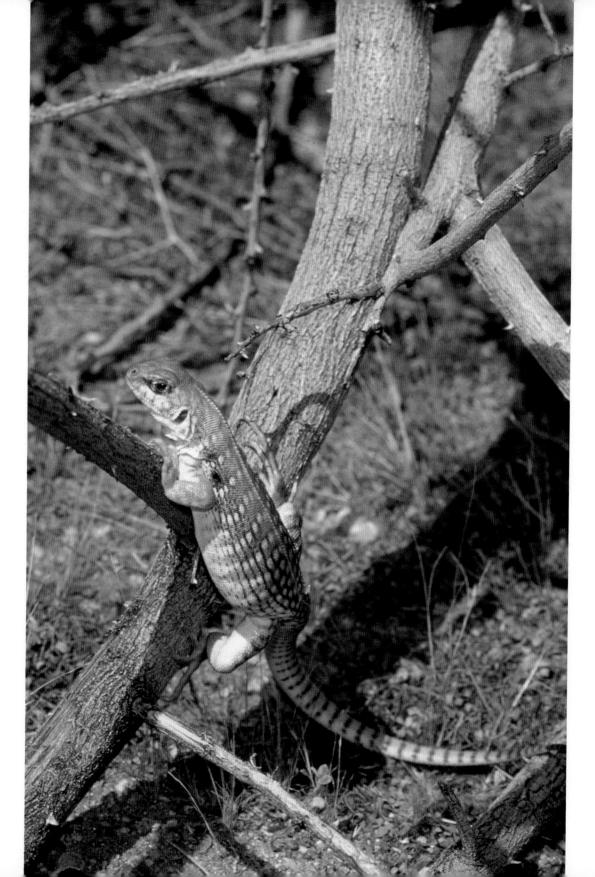

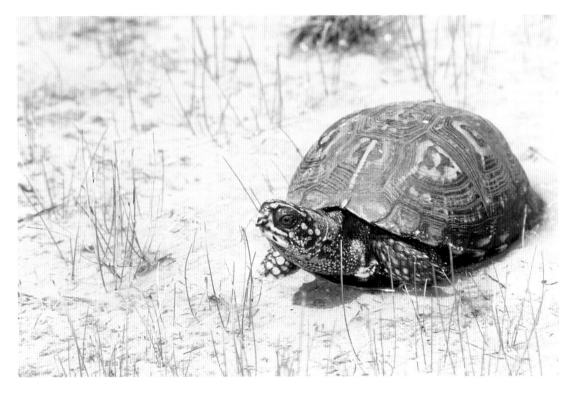

Eastern box turtle *(Terrapene carolina carolina). 70–210mm lens, f/4.5–5.6, TTL electronic flash, flash compensation dial set at -2, 100-speed film, 1/60 second, f/8, on tripod.*
This eastern box turtle was framed with a zoom lens as it crossed a marly fen. Zoom lenses in the 70–210 or 80–200 range are compact and affordable tools for photographing larger herps.

you tripped the shutter. When you do this, however, you can no longer see through the viewfinder, which is inconvenient when working on small, fast-moving subjects. Newer models usually have built-in vibration-dampening systems.

Desert iguana *(Dipsosaurus dorsalis). 200mm macro lens, 50-speed film, 1/30 second, f/11, on tripod.*
Good climbers, desert iguanas scale the branches of creosote bushes and other vegetation as they forage for both plant and insect food items. A 200mm lens gave good working distance.

Depth-of-Field Preview

For serious photography, depth-of-field preview is a must. This feature allows you to see how much of your composition will be in focus at the aperture you've selected. Normally, the lens diaphragm stays open wide until you trip the shutter. This allows as much light as possible to reach your eye while you're composing an image. But with the lens wide open, you can't tell how much of the area in front of and behind the point you've focused on will also be sharp. The depth-of-field preview button lets you manually close the diaphragm to your selected aperture so that you can see how much of the image will be in focus. When you close

11

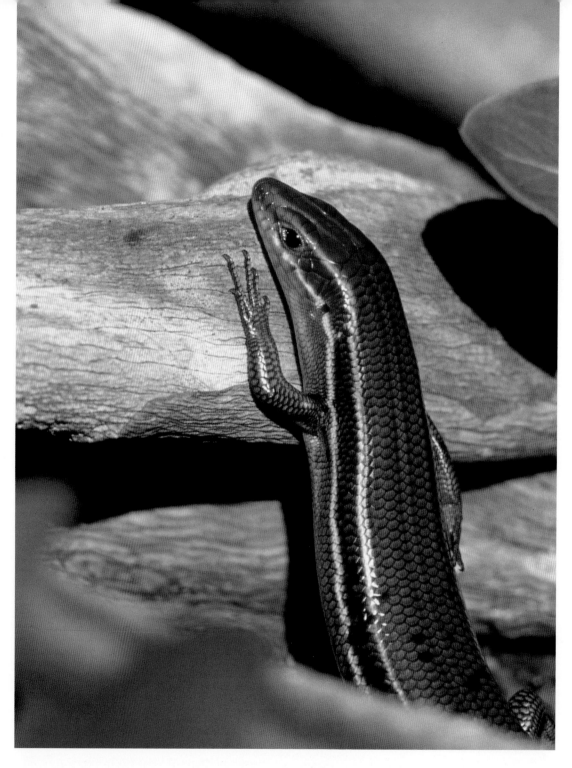

Five-lined skink *(Eumeces fasciatus)*. *300mm lens with extension tubes, 50-speed film, 1/2 second, f/11, on tripod.*
 The use of a longer lens provides good working distance for slow, careful stalking.

the aperture, you end up with less light for viewing, and some people find the darker image frustrating. The secret is to give your eye a little time to adjust to the dimmer view. With a little practice, you'll find depth-of-field preview to be indispensable.

Auto-focus

Auto-focus certainly is not the answer for every photographic situation. Most herps are slow enough to allow manual focus. There are, however, occasions when subjects such as scampering lizards or crawling snakes can benefit from auto-focus technology. The latest cameras provide instantaneous response and crisp sharpness.

TTL Flash and Flash Synchronization

Camera bodies made from the late 1980s on generally offer TTL flash capabilities. Because flash technique is so important when photographing amphibians, reptiles, and other creatures close up, we wouldn't consider buying a camera without this capability.

If you want to use an electronic flash in daylight to fill in a shadowy situation, you'll want flash synchronization at speeds up to 1/250 of a second to sharply record moving subjects and to prevent ghosting—the recording of a secondary image from ambient light. Most of the new cameras have

West with turtle setup.

Dressed in camouflage to render him less visible to passing motorists, Larry patiently waits for a Blanding's turtle (Emydoidea blandingii) *to emerge from the pond. The long lens provides working distance and allows the photographer to stay near the shore.*

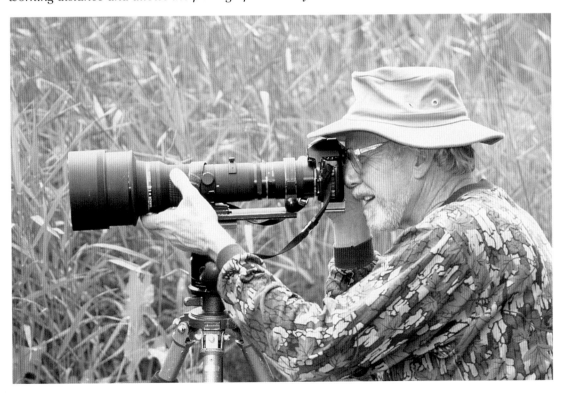

flash synchronization this fast, but be sure to look for it on older camera systems.

New Cameras versus Old

Modern SLR cameras are precise instruments capable of high-quality work. An impressive number of features crowd into their compact, high-tech bodies. One of the most convenient features is the built-in motor winder, which allows you to always have a frame of film ready to go. This is especially good for close-up work. With older cameras, many photographic opportunities were lost in the time it took to crank a film advance lever.

Also impressive are the sophisticated multisegment metering systems in these cameras. These meters are capable of calculating exposures in difficult lighting situations. They won't always meter everything properly, and they can be fooled by some situations, but by and large, they're extremely good. Almost every camera on the market also has a center-weighted and a spot meter.

All in all, modern electronic cameras are incredible systems. We would much rather have a lower-end but up-to-date camera with TTL flash, multisegment metering, and a bright focusing screen than an older top-of-the-line model without those features. For example, we'd choose a Canon EOS or a

Blanding's turtle *(Emydoidea blandingii). 400mm lens, 2X multiplier, 100-speed film, 1/125 second, f/11, on tripod.*

Basking in the warmth of a hazy spring sun, a Blanding's turtle can quickly raise its body temperature.

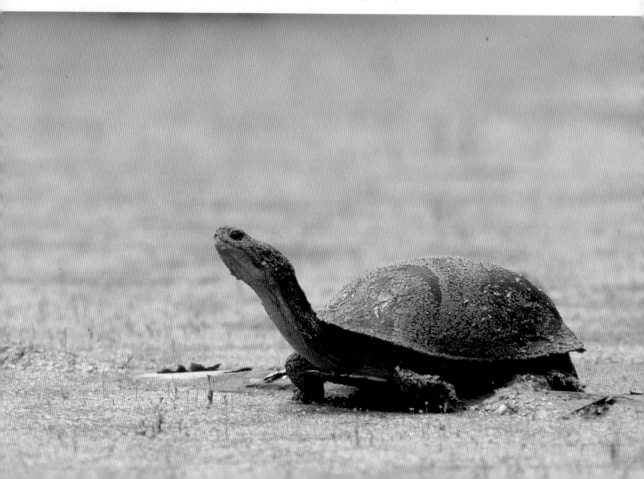

Nikon 6006, N90, or even a discontinued 8008 or 8008s over something like a Nikon F2 or F3.

Lenses

There is no one lens that will satisfy every need for photographing amphibians and reptiles. The perfect lens for creating images of a singing treefrog will not be the lens of choice for photographing a basking turtle. You need to know the kinds of lenses available and what they can do for you. We make a few suggestions here, but your lens choices will depend on your subject matter and your budget. The optics you need are those that will give you satisfactory results.

Capabilities

When choosing a lens, your subject matter and your style of photography should be your guides. What combination of focal length and maximum aperture will work best for the subjects you wish to photograph?

Focal Length. Focal length is measured in millimeters. Once, the number indicated the distance between the center of the lens and the film plane when the lens was focused at its farthest distance. Now, optics are configured differently, but we still use this numbering system. The larger the number, the greater the magnification of the scene (at a given distance) and the narrower the field of view.

Photographers talk in terms of magnification and working distance. When discussing magnification, the term *life-size* means that the subject appears life-size on the film. (A life-size image covers an area the same size as the frame of film—which is 1 by 1^1/$_2$ inches for 35mm film.) In other words, if a spring peeper hopped onto a life-size image of itself, it would be exactly the same size as its photographic likeness.

Magnification is represented as a ratio. Life-size is 1:1; half life-size is 1:2. Think of

the ratio as a fraction, and you'll be able to translate it easily.

Because your subjects are often wary and small, you need optics long enough to provide magnification from a distance so that you're not affecting the subjects' behavior. We most commonly work with lenses in the 100mm to 200mm range, although longer lenses may be needed for basking turtles or alligators. For greater magnification, we use accessory optics that allow the lenses to focus more closely.

Shutter Speed. Herps often lie motionless for long periods, and at those times, shutter speed is not a problem. Wonderful herp images can be made at slow shutter speeds with tripod-mounted cameras. But to freeze the motion of a crawling snake or a singing frog, you'll need a faster shutter speed to record a sharp image.

We almost always use small apertures to gain greater depth of field. Unfortunately, smaller apertures come at the expense of slower shutter speeds. The quick, bright light of an electronic flash helps solve the problem, allowing the use of both smaller apertures and faster shutter speeds.

Configurations

There are many options for getting the magnification you need for close-up work. The lens types most commonly used in herp photography are telephoto, telephoto zoom, and macro lenses.

Telephoto Lenses. If you already own a short telephoto lens, you can make good use of it for close-up photography. Lenses in the 85mm to 200mm range equipped with the proper close-up accessories will provide crisp images, even at greater-than-life-size magnifications. Unless you have a special need, stick with lenses that have smaller minimum apertures: for example, a 135mm, f/3.5 lens versus a 135mm, f/2 lens. They're less expensive and lighter and, more importantly, give better results.

Zoom Lenses. Zoom lenses in the 80–200mm or 75–300mm range can be excellent close-up tools, especially when teamed with a quality close-up diopter.

Macro Lenses. Designed especially for close-up photography, macro (sometimes called micro) lenses are our first choice for

Add-on accessories can greatly enhance the abilities of a prime lens. From right to left, top to bottom, are Nikon TC-301 and TC-14B multipliers, 1.4X Tamaron multiplier, and 3T and 6T Nikon close-up lenses.

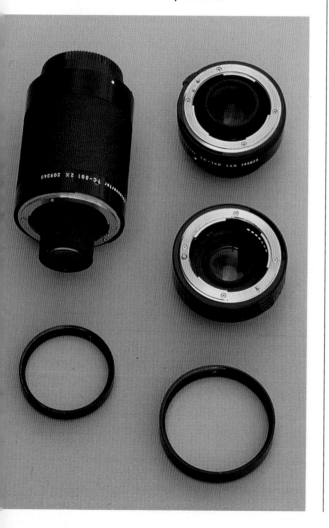

photographing most amphibians and reptiles. We prefer focal lengths in the 100mm to 200mm range. Exceptionally sharp from frame edge to frame edge, these lenses focus to half life-size. Some of the newer macro lenses go to life-size without adding accessories.

Many 180mm and the 200mm macros feature quick, smooth internal focusing—a feature we highly recommend. We especially like 200mm macros that have a rotating tripod collar. When used on a tripod or a flash bracket, the collar allows you to rotate from horizontal to vertical without moving the camera.

Close-up Lenses

Close-up lenses offer greater magnification—at a given distance. One common problem is that the longer lenses we favor don't focus closely enough to give us the magnification needed for smaller subjects. The problem is easily solved by screwing a close-up lens, or diopter, to its front.

Close-up lenses are among the most convenient accessories you can carry for fieldwork. They're compact and lightweight. They screw onto the front end of the prime lens like a filter, but they don't decrease the light available to the film or to your eye for focusing. And the newer two-element close-

American toad (Bufo americanus). 70–210mm lens, f/4.5–5.6, 4T close-up lens, TTL electronic flash, camera compensation dial set at +0.7, 50-speed film, 1/250 second, f/16, handheld.

Adding a quality multielement close-up lens to a medium telephoto zoom greatly extends the lens's focusing range. Set at 70mm and focused at infinity, this combination covers 5:1. At 210mm and focused to its nearest point, you're nearly at life-size—close enough to make tight portraits of subjects such as this American toad.

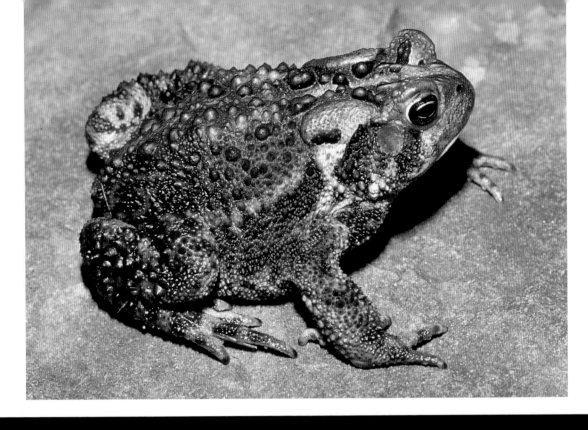

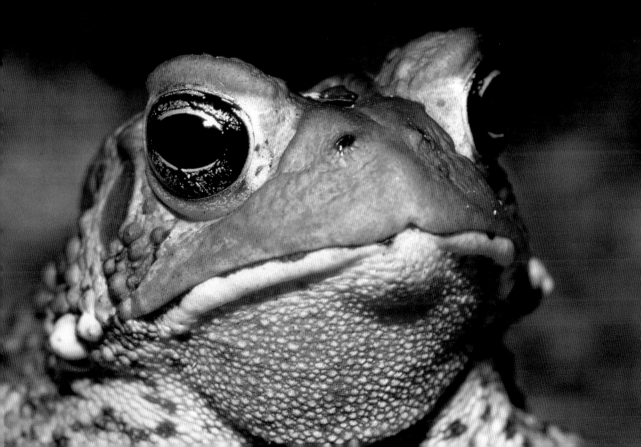

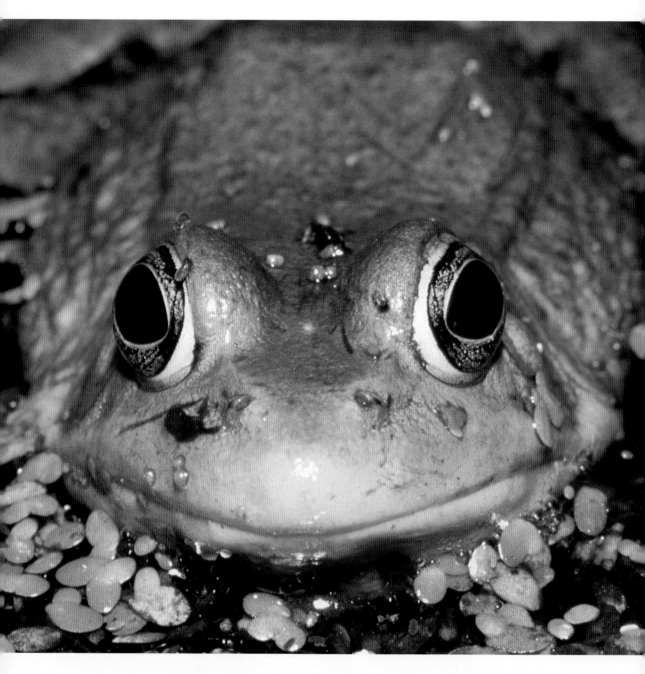

Green frog *(Rana clamitans)*. *105mm macro lens, Tamaron 1.4X multiplier, TTL electronic flash, camera compensation dial set at +0.3, 100-speed film, 1/250 second, f/16, on tripod.*
 In some situations, it's difficult to get close enough to the subject to properly frame the composition. Increasing the focal length of the prime lens by adding a multiplier can go a long way toward solving this problem.

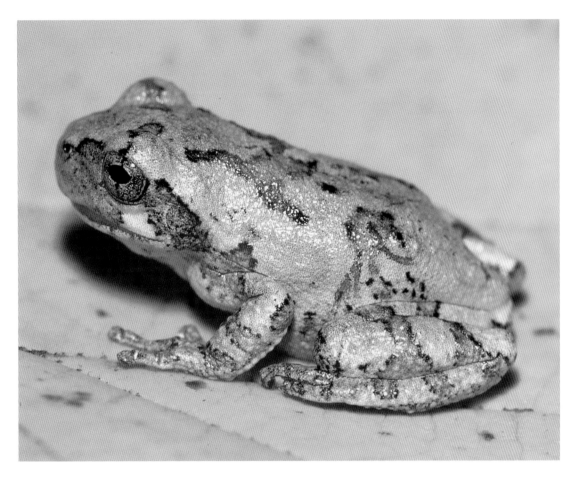

Gray treefrog *(Hyla versicolor)* on autumn leaf. *200mm macro lens, 3T close-up lens, 1.4X multiplier, TTL flash, camera compensation dial set at +1, on tripod.*

Add-on accessories allow the long macro lens to focus closer and still retain good working distance. The electronic flash provided light on a dull day, and the tripod kept everything sharp and well framed for a series of exposures.

up lenses (as opposed to cheaper single-element models) offer high optical quality. Nikon, Canon, Minolta, and Leitz, as well as some aftermarket houses, make them in several sizes to fit most lenses.

Nikon makes two sizes with two strengths in each size. Century Precision Optics makes high-quality, if pricey, close-up lenses in two sizes, which are especially good for people using large-aperture zooms.

Close-up lens power is typically expressed in diopters: +1, +2, +3, and so forth. Any given diopter strength brings you to a given working distance from your subject, regardless of the focal length of the primary lens. A +3 lens is stronger than a +2 and will bring you closer to your subject. Camera manufacturers' model numbers don't necessarily correspond to diopter strength. For example, Nikon's 3T and 5T close-ups lenses are

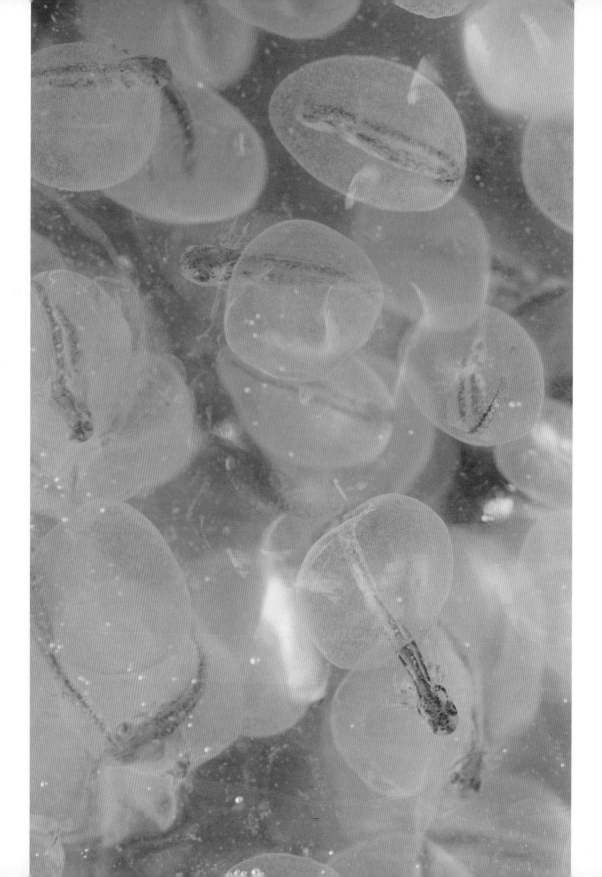

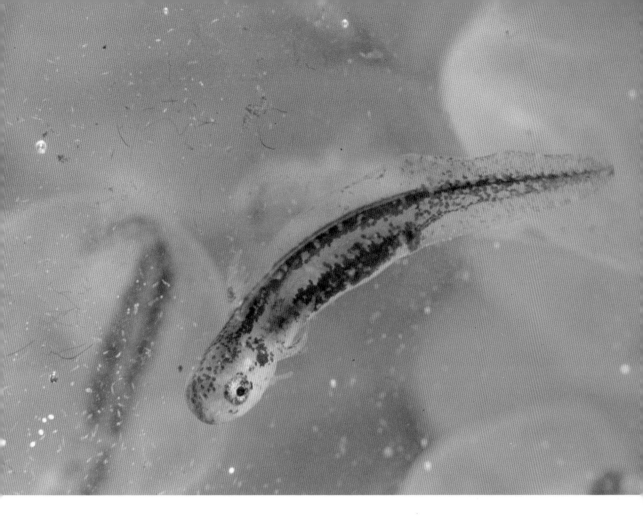

Larvae of Northwestern salamander *(Ambystoma gracile). 200mm macro lens, 1.4X multiplier, 4T close-up lens, 50-speed film, 1 second, f/16, on tripod.*

These larvae were still in the gelatinous egg mass when they were removed from a mountain pool and placed in a clear container to be photographed. Once the pictures were made, the egg mass was immediately returned to the pool so the eggs were not harmed. Add-on accessories allowed these small subjects to be recorded at a large image size.

both +1.5 diopter (in different filter sizes). Likewise, its 4T and 6T are both +3 diopter. Canon's 500T is +2 diopter.

To gain magnification while keeping as much working distance as possible, attach the close-up lens to a longer prime lens—a 200mm macro lens works especially well. When working with close-up lenses, this focal length provides much more versatility than a 105mm macro. For instance, if you can get to half life-size (1:2) with a close-up

lens on a 105mm macro lens, that same close-up lens on a 200mm macro lens would give you life-size (1:1). You get a larger image for the working distance, which means that you're less likely to disturb your subject, and you have more room to maneuver the camera to keep from blocking the light source.

Keep in mind that adding a close-up lens decreases the effective focal length, which makes the lens combination easier to hold

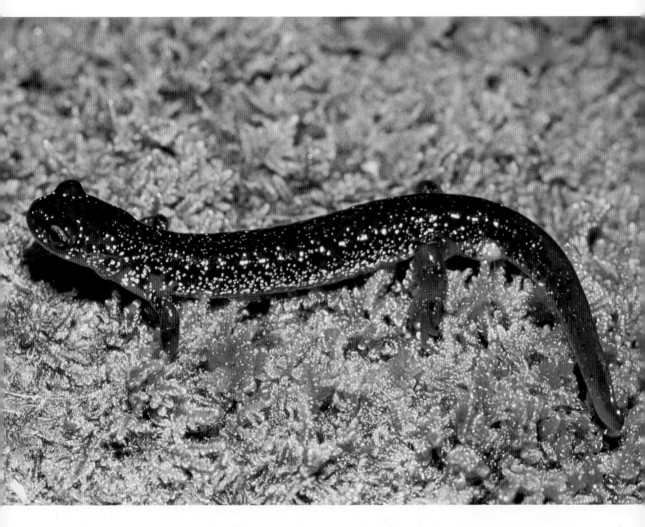

Cascade torrent salamander *(Rhyacotriton cascadae)*. *105mm macro lens, 3T close-up lens, TTL flash, camera compensation dial set at +1, 50-speed film, 1/250 second, f/16, handheld.*
Combining a close-up lens with an older 105mm macro lens provides adequate working distance with a very compact setup. A small TTL flash helped keep the outfit lightweight and user-friendly.

by hand. This can be an advantage when working with flash, because when the flash and lens are closer to the subject, the light has more intensity, allowing smaller apertures. For smaller subjects such as amphibian egg masses or newly metamorphosed Pacific treefrogs *(Hyla regilla)*, we commonly use a +3 close-up lens on the front of a 200mm macro, providing a range of coverage from roughly 77 by 111mm to 27 by 41mm.

On some lenses such as older long macros, close-up lenses work best in reversed position. You can reverse close-up lenses by using a male-to-male ring available

from Kirk Enterprises (see "Resources"). At least one lens, the 200mm Nikkor ED Macro, requires the close-up lens element to be reversed in its mount. This is best accomplished by a camera repair person.

Multipliers

Multipliers are valuable aids for getting larger images. Also known as tele-extenders or doublers, multipliers fit between the prime lens and the camera.

As the name suggests, multipliers multiply the focal length of the prime lens. A 1.4X multiplier attached to a 200mm lens yields an effective 280mm. A 2X multiplier attached to the same lens results in an effective 400mm. Multipliers also increase the magnification in close-up work by the power of the multiplier. If you're working at life-size (1:1), attaching a 2X multiplier behind the same equipment would bring the image to twice life-size (2:1) without changing the working distance. However, because the focal length has increased, holding the camera by hand becomes more difficult. When using multipliers, it's easier to focus and compose images while working off a tripod.

There are problems to be aware of with multipliers. As you increase the power of the multiplier, you decrease sharpness and contrast. The secret to getting good results is to use a quality prime lens and good photographic technique.

Multipliers also multiply—and therefore diminish—the effective aperture, so less

light is available to the film. For instance, if you have a 200mm primary lens that opens to f/4 at its widest aperture, adding a 2X multiplier would effectively change that aperture to f/8. If you start at f/4 with a 1.4X multiplier, you would end up at f/5.6.

Extension Tubes

An extension tube is a simple hollow metal spacer that fits between a lens and the camera body. Any lens combination focuses more closely with added extension. Extension tubes increase magnification by moving the lens or lenses farther from the film

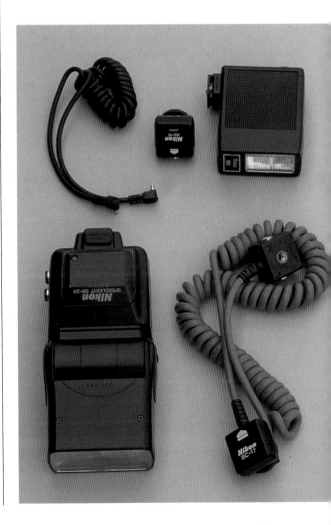

Close-up flash permits you to get photographs that simply cannot be made any other way. From top to bottom, left to right, are an off-camera cord for a small manual flash, a hot shoe adapter to use a manual flash off-camera with a camera lacking P.C. contacts, an old manual flash unit, a modern TTL flash, and an off-camera TTL flash cord.

Photographing tailed frog (Ascaphus truei) *tadpoles in a quiet pool along a mountain stream, Bill braces his elbow on his knees to secure composition and focus.*

plane. These tubes are inexpensive devices that can be bought singly or in sets. (A bellows is another form of extension, but for many reasons, it is less practical for fieldwork.) If you decide to invest in extension tubes, be sure to look for a set that maintains the camera-to-lens metering and automatic aperture control connections.

In the past, extension tubes were the primary tool for close-up photography. Today, there are better options, so they are not used nearly as often. They are, however, a workable and inexpensive method of increasing magnification. And there are occasions when extension tubes still come in handy, such as when you need slightly more magnification than a close-up lens setup provides. Extension tubes work well in combination with close-up lenses and multipliers to maximize magnification for tiny subjects.

Flash Equipment

Flash equipment is used extensively when photographing herps. The ability to manipulate light, to add it in degrees from any angle, and to use it to maintain small apertures for greater depth of field is too important for photographers to ignore. Recent developments in TTL flash technology have made these units much more user-friendly.

We find that it is best to keep your flash equipment simple and easy to use. We recommend investing in a fairly powerful TTL flash made by the same manufacturer as your camera. If you're using predominantly longer lenses, such as an 80–200 macro

zoom or a 200 macro, choose a larger flash (such as Nikon's SB-26). If you're using lenses 105mm or shorter for your close-up work, one of the smaller units on the market (such as Nikon's SB-23 or Canon's 430 EZ) will work just fine.

Look for a TTL flash system that allows you to vary the relationship between the light output of the flash and the natural light exposure. This greatly simplifies fill-flash photography.

TTL flash meters monitor light at the film plane, then adjust the flash output accordingly. Keep in mind that the TTL flash exposure is determined by a separate flash meter built into the camera body. The exposure patterns for these flash meters may be very different from that of the camera's other built-in meters. (See the "Flash Photography" section for more details.)

Macro Flash Rings

Some photographers swear by macro flash ring lights. We don't find them useful or desirable for photographing herps, because they do not have enough light output and the lighting is too flat and doesn't provide the detail and feeling of sharpness we want.

Flash Brackets

When photographing herps, moving the flash unit off the camera's hot shoe gives you a better, more natural angle for the light. To do this, you need a dedicated flash cord, preferably one made by your camera's manufacturer, or you run the risk of locking up or ruining your equipment. You also need some sort of mounting bracket for the flash, because if you're photographing handheld or on a tripod—especially with 105mm or longer lenses—you need some way of holding and positioning the flash while your hands are busy operating the camera.

There are some wonderful flash brackets on the market. We both use one offered by Kirk Enterprises (see "Resources"). The

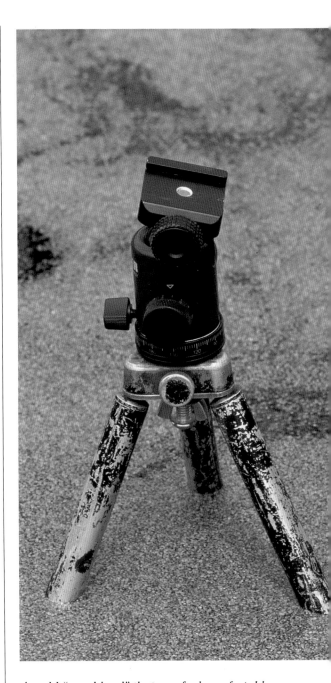

An old "pond 'pod" that you feel comfortable carrying into shallow water can be a life-saver for photographing events that require long waiting while holding a composition, such as recording singing frogs.

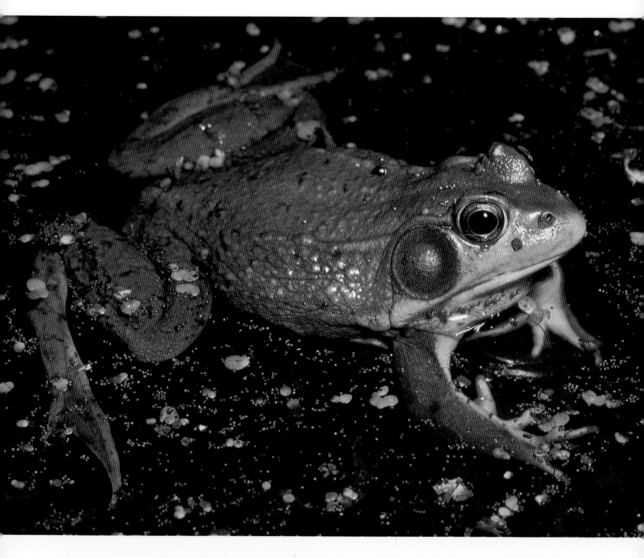

Male Green frog *(Rana clamitans)* on pond's surface. *105mm macro lens, manual electronic flash, 25-speed film, 1/60 second, f/11, on tripod.*
An old tripod set up in the water provided precise framing and focus of this male green frog, allowing several identical photographs to be made.

bracket we use is strong enough to support the largest flashes securely, it's adjustable, and it allows us to easily switch between horizontal and vertical compositions. Be careful when investing in flash brackets, however. Many were designed for use with small manual flashes and are not strong enough to support the heavier TTL units.

Support
Sturdy support for your camera is as important to the creation of quality photographs

as is an understanding of composition or the type of equipment you use. Sturdy support can spell the difference between a sharp, crisp image and a soft, blurry one. Good camera support also allows you to keep the subject in focus and maintain the desired composition. How you maintain solid camera support depends on the circumstances you encounter in the field. Let's explore some options.

Tripods

The most versatile support for photography is a good, sturdy tripod—one with substantial mass. The challenge for nature photographers in selecting a tripod is finding the right balance between one that is small enough to carry in the field and one that is heavy enough to support the equipment. A good tripod is so critical for sharpness that you're better off carrying fewer lenses or camera bodies in favor of a heavier tripod.

Gray treefrogs *(Hyla versicolor)* in amplexus. *105mm macro lens, 27mm extension tube, manual electronic flash, 25-speed film, 1/60 second, f/11, handheld.*

As valuable as a sturdy tripod can be, there are some situations in which only a handheld camera provides the needed flexibility and speed of operation. In this case, the wader-clad photographer holds the camera just above the water's surface for a frog's-eye view of these mating frogs.

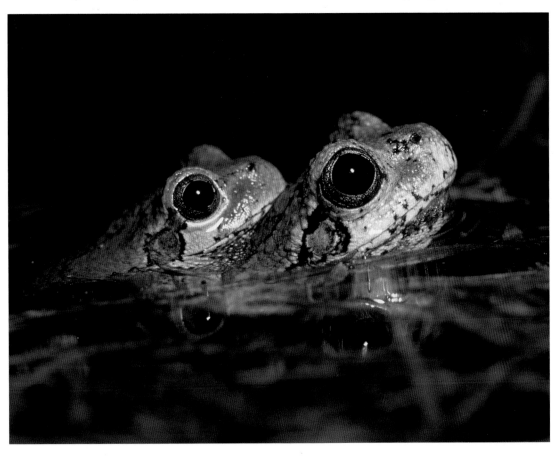

In selecting a tripod, there are a couple of factors that should be considered. First, the legs should extend enough to raise the camera to your standing eye level without any center-post extension. On any tripod, center-post extension exaggerates the wobbles that you're trying to avoid. The tripod legs should also spread far enough to bring the camera very close to the ground. For most herp work, we use Gitzo tripods—the standard 320 with a short center post, or a modified 326 that has no center post. Bogen also makes several models that are excellent for fieldwork.

Ring-necked snake *(Diadophis punctatus)*. *105mm macro lens, TTL electronic flash, camera compensation dial set at +0.7, 50-speed film, 1/250 second, f/11.*

The motion-stopping capabilities of full flash made it possible to photograph this agile, quick-moving ring-necked snake before it disappeared beneath the rocks on a hillside in southwestern Washington.

The two most popular tripod head designs are pan-tilt heads and ball-socket heads. Pan-tilt heads offer great precision through individually adjustable controls that govern movement along three axes. These heads let you fine-tune and lock down each adjustment, which comes in handy when you have lots of time to set up and compose a photograph. For herp photography, however, where a speedy response is often critical, these heads are not our first choice. We prefer a heavy ball-socket head. The original model is the classic Arca Swiss Mono-ball. Today, there are many Mono-ball clones on the market, in various sizes and configurations. We like several models of ball heads manufactured by Arca and Kaiser.

The sturdiest ball heads feature a large, Teflon-coated ball encased in a rugged frame. They're massive enough to support long, heavy lenses. If you're using shorter macro telephoto lenses in the 100mm to 200mm range, smaller ball heads work just as well and weigh considerably less—a real advantage when carrying equipment around in the field. The ball-and-socket construction allows you to maneuver your camera and lens freely, then quickly lock it into place.

Look for heads that offer a separate, smooth pan control, so that you can follow the action of moving creatures without unlocking the main controls. Also look for comfortably located locking levers and knobs—ones that you can adjust without taking your eye from the viewfinder.

Tripod Heads

Even the sturdiest tripod is not much good without a good head on its shoulders. A tripod head is essentially a mechanical joint that is placed between the camera and tripod, allowing you to tilt and turn your camera and lens in any direction quickly and easily.

Wandering garter snake *(Thamnophis elegans vagrans). Above: 200mm macro lens, TTL electronic flash, flash compensation dial set at -1.7, 50-speed film, 1/30 second, f/16, on tripod with 81A warming filter. Opposite page: without 81A warming filter.*

Both of these photographs were taken using fill flash. An 81A warming filter was used on the photograph above to neutralize the cold, early-morning light, which produced the bluish cast seen in the image opposite.

Quick-Release Plates

Quick-release plate systems make it easy to change lenses or camera bodies. Our favorite is a heavy Arca system with dovetailed plates that slide back and forth, often eliminating the need for an extra focusing rail.

Another good quick-release system is the Bogen hexagonal plate system. The Bogen system is sturdy but is fixed within the mount, so it is not quite as responsive as the Arca design.

Film

Choosing which type of film to put in your camera can be more mystifying than choosing the camera itself. At the rate that new films enter the market, even professional photographers—whose film loyalties run deep and strong—find themselves confused.

Film speed is expressed by an ISO (International Standards Organization) number. (Old-timers remember these as ASA numbers, but ISO is the measurement recognized by film manufacturers around the world today.) ISO numbers describe the film's sensitivity to light. The lower the number, the slower the film. Slow films, those of ISO 25 to 64, require more light to record an exposure but generally offer finer grain and thus sharper images.

Many modern films stand head and shoulders above those available in the past. There are ISO 100 films today that are technically as good as the best ISO 25 films of 15 years ago. An ISO 100 film is two stops faster than ISO 25, which allows much greater flexibility in deciding what shutter speed and aperture to use to stop action or gain depth of field in low-light situations. Some 100-speed films can be pushed to ISO 200 with little loss of quality, which allows you to work in even dimmer light. Coupled with fast lenses, these films make it possible to photograph action even in predawn and twilight hours.

If you work with color print film, you'll find a wide range of good films from ISO 25 all the way up to ISO 400.

Color Negative, E-6, or K-14

Professional and amateur nature photographers tend to use transparency films. When we talk about transparency film, we're really talking about two types: coupler-in-emulsion (or substantive) films and coupler-in-developer (or nonsubstantive) films. Coupler-in-emulsion films are also called E-6 films; coupler-in-developer films are known as K-14 films.

With the E-6 films, color coupler molecules embedded in the emulsion form dyes that create color in the transparency. Examples of these films are the Ektachrome and Fujichrome films. With coupler-in-developer films, the color is produced during the K-14 developing process. These are Kodak's Kodachromes.

At this writing, it's impossible to point to any one film that is the hands-down best for herp photography. We know that we want sharpness, good color, and as much speed as we can get without losing detail or color.

Sharpness and Speed

In choosing film, photographers are caught in a conflict between sharpness and speed.

Canyon treefrog *(Hyla arenicolor). 105mm macro lens, 81C warming filter, 25-speed film, 1 second, f/11, on tripod.*

Resting on the rock wall of an Arizona canyon, this treefrog proved an easy subject for a tripod-mounted camera and a long natural light exposure. A warming filter neutralized the cool tones in the shade of a blue-sky day.

In general, the faster the film, the more grainy the image. In close-up work, slow, sharp film gives the best results, but it limits the shutter speed and depth-of-field options. (This is another reason that mastery of flash techniques is so important to close-up photographers.)

We prefer slow- to medium-speed slide films in the ISO 50 to ISO 100 range. ISO 100 films have improved tremendously in the last few years—a trend that's likely to continue.

In natural light, faster film provides faster shutter speeds, which help freeze the movements of an animal (or of the photographer). ISO 100 film offers more options with flash photography as well. Used with a 105mm lens, it allows you to make do with a smaller, cheaper, lighter flash without sacrificing depth of field. Once, when photographing red-spotted toads *(Bufo punctatus)* at night, we needed f/11 for acceptable depth of field, but we each got there with a different setup. One of us used a 105mm macro lens, a Nikon SB-23 flash, and ISO 100 film; the other used a 200mm macro lens, the larger SB-24, and ISO 50 film.

Stay Tuned

We tend to use only one or two types of film. By doing so, we avoid having to learn and remember the nuances of several different types. We prefer to learn how a couple of films behave in different situations and then stick with them.

Currently, our films of choice are Fuji's Velvia 50 and Fuji's Provia 100 for most of our amphibian and reptile photography. These films provide exceptional color saturation and sharpness. Velvia 50 provides the best color saturation we have found in a slide film. Provia 100 provides an additional stop of light when we need the extra speed, with only a slight loss in color saturation.

However, we must also state that advances in film technology are occurring rapidly. It is important that you stay tuned to the latest advances by reading photography magazines and talking to other photographers.

"Starter Package" for Herp Photography

A few carefully selected pieces of equipment are all you need to get started in herp photography. A 35mm camera body is the obvious place to begin. If you're purchasing a body, seriously consider a newer model with TTL flash capability. Add to that a short telephoto lens somewhere in the range of 105mm (preferably a macro lens) and a TTL flash for added flexibility. As your photographic interests expand, you may want to add a tripod and an additional lens or two. However, these three pieces of gear will meet many, if not all, of your herp photography needs.

PART·TWO

Photographics

In his book *The Keepers of Light*, William Crawford states, "The syntax for photography is technology." In other words, the combination of technical elements that photographers use shapes what and how we see photographically. Technology sets the limits of what we can communicate through our work and how we approach our subjects.

As camera manufacturers introduce new technology, we make an effort to learn more about it. Will it help solve long-standing problems we've had in getting a certain type of image? Does it open up new approaches, thus opening our eyes to new ways of seeing? Not all advances do. But the more mastery we have of the technological syntax, the better we can record our visions on film, be they herps or grand landscapes.

Exposure

How do you determine a correct exposure? It's a question that often plagues beginning photographers. Even experienced photographers sometimes become mired in uncertainty in tricky situations.

Reciprocity

We talk about exposure in terms of *stops*. A stop is simply a doubling or a halving of either shutter speed or lens aperture. For example, a shutter speed of 1/30 of a second is one stop more light than 1/60 of a second and one stop less light than 1/15 of a second. Likewise, an aperture of f/11 lets in one stop less light than an aperture of f/8 and one stop more than f/16. (The f-stop numbering sequence may seem strange at first, but remember that the numbers represent the area of the circular lens opening.)

For any given photographic situation, you can achieve the same exposure using a variety of f-stop and shutter speed combinations—choosing a slow shutter speed and small aperture or a fast shutter speed and large aperture. A shutter speed of 1/30 of a second and a lens aperture of f/16 give you the same exposure as 1/125 of a second at f/8, 1/250 of a second at f/5.6, 1/500 of a second at f/4, or 1/1,000 of a second at f/2.8. This relationship is called *reciprocity*. The resulting images will look different, but they will all have exactly the same exposure.

Films are available in speeds that are pretty much direct numerical doublings and halvings, and you can think of films in terms of stops as well. An ISO 50 film is one stop slower than an ISO 100 film and one stop faster than an ISO 25 film.

Shutter Speed or Depth of Field?

Understanding reciprocity allows you to choose between depth of field and shutter speed in any given photographic situation.

Eastern garter snake *(Thamnophis sirtalis sirtalis)* on snow. *75–150mm zoom lens, TTL flash, flash compensation dial set at -2, 50-speed film, 1/4 second, f/16, on tripod.*

Although this exposure may look tricky, it wasn't. Snow without detail is 2.5 stops more reflective than a gray card, so a meter reading off the snow was opened up 2.5 stops, giving a literal translation to the medium-tone snake. Because of the dull, overcast light, a weak fill flash was used to put a highlight in the eye.

If you are photographing a swimming turtle or a green crested basilisk *(Basiliscus plumifrons)* running across the water, you'll probably want the fastest shutter speed you can get. At other times, when your subject is not moving and you need greater depth of field, you'll use a smaller aperture (f/11, f/16, f/22, or even f/32) and a longer exposure. Even with moving subjects or moving backgrounds, such as flowing water, there are times when you might decide to use a slower shutter speed to blur the image and thus emphasize the movement.

Proper Exposure
There are many ways to calculate an exposure. Exposure can be determined simply by working in known conditions and estimating the amount of light. A big problem with estimated exposures is that they lock you into

working only in known situations. Another problem is that even "known" situations aren't always what you think they are.

It's far better to measure the light with an exposure meter. As we've mentioned, modern cameras have sophisticated metering systems. Most have meters that read patterns in your composition and estimate the exposure. Many also have spot meters that allow you to measure the light on a small area of your composition. Once you're used

Side-blotched lizard *(Uta stansburiana)* clinging to lichen-covered rock face. *200mm macro lens, 1.4X multiplier, TTL electronic flash, camera compensation dial set at +0.7, 50-speed film, 1/250th second, f/11, on tripod.*

The long working distance and high magnification provided by the 200mm macro lens used with a 1.4X multiplier enabled this skittish side-blotched lizard to be stalked successfully.

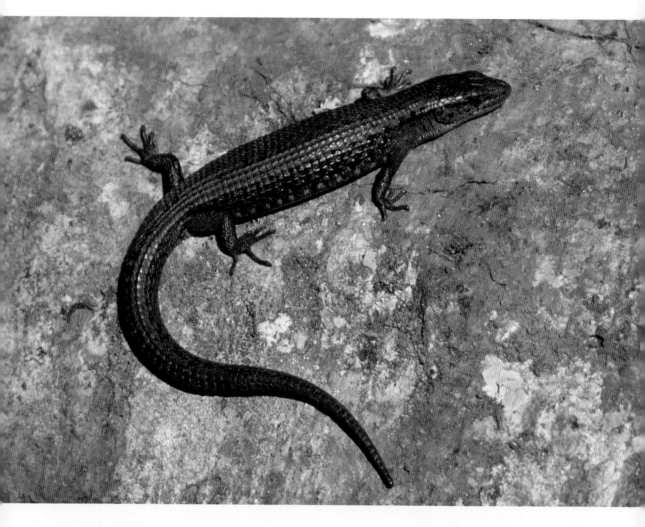

Northern alligator lizard *(Elgaria coerulea principis)* on a red alder log. *100mm lens, 27.5mm extension tube, 64-speed film, 1/30 second, f/11, on tripod.*

Female northern alligator lizards, such as the one shown in this photograph, can be distinguished from males by their relatively narrow jaws. Males use their strong jaws to grasp on to the female's neck during mating, which may last approximately twenty-four hours.

to thinking in tonalities and working in stops, you can use that information to nail down the exact exposure you want.

People often talk about *bracketing*. Bracketing is deciding what the exposure should be and then making additional images at exposures on either side in the hope that one will be right. We prefer not to bracket except when working in tricky exposure situations or with strange equipment. When you bracket, you waste film: at least two-thirds of your images won't be properly exposed. And you can count on the fact that the perfect pose or dramatic bit of behavior

you wanted to record will be on one of the poorly exposed frames.

Imagine photographing toads singing at night with a handheld camera while kneeling in foot-deep water. You'll probably expose a roll of film just to get one good, sharp composition that shows exactly what you want. And you would be terribly disappointed if that one frame was poorly exposed. You'll save a lot of aggravation and a lot of film if you learn to understand tonalities and to work in stops.

Seeing Tones

Within every photograph, there is a range of distinct tones or levels of lightness and darkness in which the details of the scene are recorded. Photographers distinguish levels of tonality ranging from detail-less light to detail-less dark. Ansel Adams described these levels as zones.

Tonality can also be thought of in terms of stops: each full tone is one stop lighter or darker than the next. Slide films can record

Eastern garter snake with blurred tongue. *200mm macro lens, 50-speed film, 1/15 second, f/8, on tripod.*

This exposure was a compromise between shutter speed and aperture. An aperture of f/8 was chosen to get sufficient depth of field to cover the snake while still being shallow enough to blur the busy background. The 1/15 of a second shutter speed allowed the flicking tongue to blur enough to imply motion.

continuous tonality over a range of only about three stops on any given frame. Thus, they're the most unforgiving in terms of exposure: if you're one stop off, you won't get a usable image.

A simpler way to think about this is that you cannot record detailed black and

American alligator *(Alligator mississippiensis)*. *400mm lens, 25-speed film, 1/60 second, f/8, on tripod.*

This photograph is composed mainly of the three middle tonal values—dark, medium, and light—an easy range for the film to handle.

detailed white in the same photograph. In high-contrast situations, you have to compromise.

Five easy-to-recognize tonalities are most useful in helping determine proper exposure.

Whitish. Detail-less white, such as snow without detail. The tone of the white side of a photographic gray card. Two and a half stops lighter than medium.

Very Light. The tone of fresh snow with detail. Two stops lighter than medium.

Light. The tonal value of most yellow flowers and most sands. One stop lighter than medium.

Pine woods treefrog *(Hyla femoralis)*. *105mm macro lens, 27.5mm extension tube, manual elec-tronic flash, 25-speed film, 1/60 second, f/16, handheld.*

This composition encompasses a limited tonal range. Everything in the frame is near medium tonality, allowing a literal translation of the entire area.

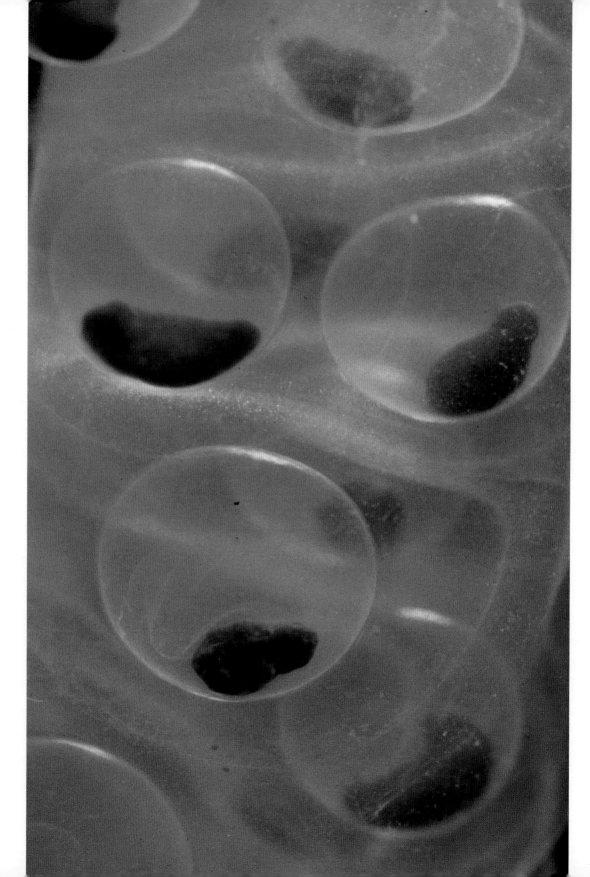

Medium. The tone of most green grass or the northern blue sky at midday. The tone of a photographic gray card.

Dark. The tone of many tropical broad-leaved plants, red oak and Douglas-fir bark, and most dark salamanders. Two-thirds to one stop darker than medium.

Tone is color-blind; any color can have any tonality. For example, you can have medium red, light red, very light red, and so on. The camera's light meter reads the tonality of all colors equally.

Our eyes automatically adjust for the range of tones they encounter, making it difficult to see in terms of the tonalities of the objects around us. With a little practice, however, this ability becomes second nature.

Using Tonality

Meters assume that whatever you point them at is medium tone—halfway between light and dark. The question you have to ask is: What is the tonality of the subject? The answer allows you to interpret the meter's reading to get the exposure you want. In natural history photography, we usually want a literal translation of the scene. In other words, we want the subject on the film to look like it did in reality.

Someone once said that proper exposure is what you like. That may be true, but it ends any further discussion. To communi-

Spotted salamander *(Ambystoma macula-tum)* embryos. *105mm macro lens, 52.5mm extension tube, manual electronic flash, 25-speed film, 1/60 second, f/11, on tripod.*

The salamander eggs were placed in a small aquarium. One flash was directed at the eggs straight down from above, and a second flash was placed to the front and far enough to the side to avoid reflections off the glass. As soon as the photography was finished, the eggs were returned to the pond they came from.

cate concepts of exposure, we need a better definition of exposure. We find it most useful to work with a literal translation of the scene as our starting point, where medium-tone objects in the scene appear medium tone in the image. Then we can adjust the exposure as needed to compensate for overly bright or dark areas.

Slide film can record a range of about three continuous stops in any one image—for example, from light to medium to dark. If your composition has a greater tonal range, you simply cannot record it as you see it.

At any instant in any scene, there is one amount of light. At this moment, wherever you're reading this book, there is only one amount of light. To get a literal translation in this situation—at least in the middle three tonal areas—all you need to do is meter a photographic gray card or other medium-tone object in the same light and take the picture at that exposure.

Most subjects contain a range of tones. Even if you're photographing the palm of your hand, which is all pretty much the same overall tonality, there are lines with slight shading, especially in directional lighting. A high-contrast subject may contain tonalities from detail-less white at one end to deep shadows at the other.

Many herps have high-contrast patterns that make it impossible to accurately record their entire tonal range on film. A Mojave black-collared lizard (*Crotaphytus bicinctores*), for example, covers a four-stop tonal range (see page 91). Most areas of the lizard are medium tone. However, the black collars are one stop darker than medium, and areas around the eyes and between the collars are two stops lighter than medium. A literal-translation exposure gives good detail and color saturation for most of the lizard, but the lizard's dark collars lack detail, and the very light areas look washed out. Given both the limitations of the film and the wide tonal range

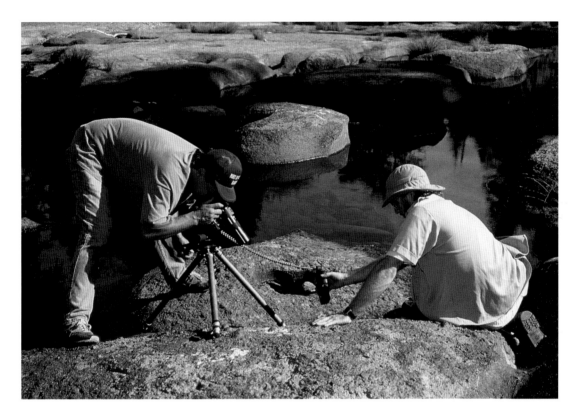

of this subject, this is the best exposure you can get.

The tonal difference is the same whether the light is overcast or bright directional sun. But bright directional sun creates brighter highlights and deeper shadows, compounding the problem.

The film's tonal limitations can also be advantageous in photographing silhouettes. Say you have a lizard on a branch backlit

While Bill operates the camera, a friend holds an electronic flash in a sidelight position to illuminate a foothill yellow-legged frog on the bottom of a clear stream.

against a bright sunset. Exposing for the sunset leaves the lizard in dark silhouette but still recognizable as a lizard. Such lighting situations can be used to create dramatic images.

Foothill yellow-legged frog *(Rana boylii)* in a Cascade stream. *Top: natural light, 200mm macro lens, 50-speed film, 1/4 second, f/11, on tripod. Bottom: full flash, 200mm macro lens, camera compensation dial set at +0.3, 50-speed film, 1/250 second, f/11, on tripod.*

In the top photo—made with existing natural light—the area beneath the water is hidden by the reflection of the overcast sky on the water. Under the right conditions, this can be very pleasing aesthetically. A polarizing filter would eliminate some of the reflection but would lower the shutter speed to the point where even the slow-moving water would cause subject movement. Using electronic flash sharply to the side so that it enters the water outside the picture area makes the water disappear almost completely, revealing much more detail on the stream bottom.

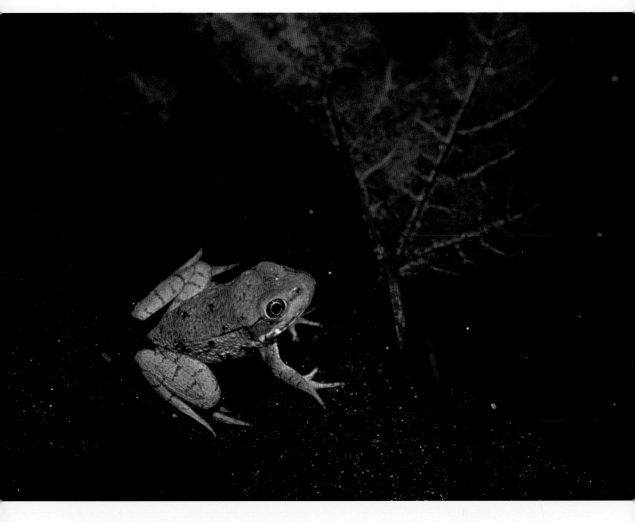

Green frog on bottom of pond. *105mm macro lens, 3T close-up lens, TTL flash, camera compensation dial set at +0.3, polarizing filter on lens, polarizing filter on flash, 100-speed film, 1/250 second, f/8.*

Combining a single angled flash and cross-polarization eliminated all specular highlights, allowing a crystal-clear view below the surface of the water.

Light Meters

The camera's reflected light meter reading of the subject is the easiest and best place to start when determining an exposure in the field. But remember that the camera can't think for you, and its meter assumes that what it's pointed at is medium tone.

With reflected light meter readings, it's up to you to consider the tonality of the subject and to adjust the exposure reading as needed.

Working in manual mode, you can simply open or close the lens aperture. You'll probably open up for light subjects (because the

meter will darken them to medium, but you want them to be the light tone they actually are) and close down for dark subjects. To record detail in snow, you need to open up about two stops.

A good exercise to see how tonality affects a meter is to take a photographic gray card and meter the gray side. Put the camera in automatic exposure mode, fill the frame, and take an exposure. Next turn the gray card over so that you're looking at the 90 percent reflectance side and do the same thing. You'll notice that the camera's exposure reading is quite different, but when the slides come back, you'll see that they are both rendered as a medium tone.

Keep in mind that the f-stop marks on a lens are accurate only when the lens is focused at or near infinity. This is another reason that TTL meters are desirable for close-up work, for long lens work, or with variable-aperture lenses. Today's TTL meters are so sophisticated that there's no reason to carry a handheld meter.

Metering Techniques

If the tonalities in your subject fall in a three-tone range around medium—that is, it contains light tones, medium tones, and dark tones—you can meter any medium tone in the composition and expose it as such. Or you could meter a dark tone or a light tone and work in stops to determine the exposure for a literal translation.

One helpful technique is to meter a substitute object of known tonality in the same light as your subject. You can carry a gray card around with you and meter it to determine the literal-translation exposure. We often meter the palms of our hands to determine the literal-translation exposure. Regardless of race or ethnicity, the skin on the palm of the hand is almost always lighter than medium. The exact difference can be determined by comparing the meter reading from your hand to that

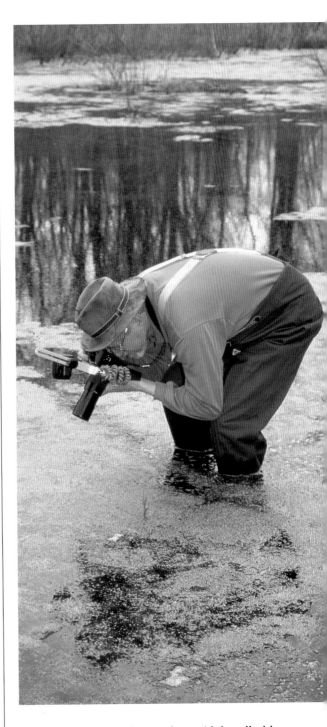

Larry in pond wearing waders with handheld flash rig.

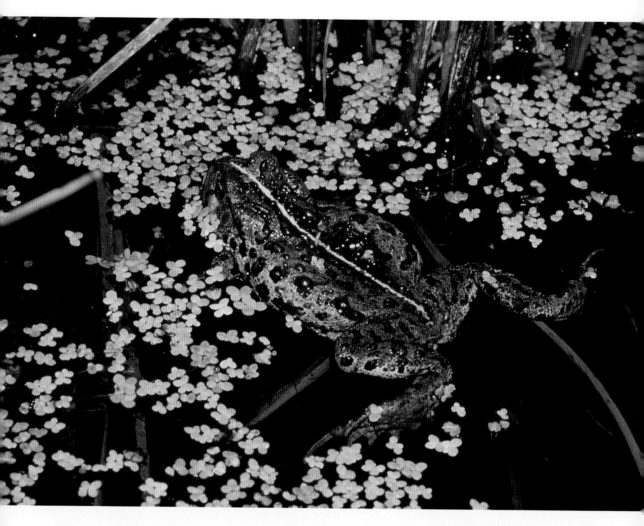

Boreal toad *(Bufo boreas boreas)* floating on duckweed-covered pool. *105mm macro lens, TTL flash, camera compensation dial set at +0.7, 100-speed film, 1/250 second, f/11, handheld.*
The handheld close-up flash setup permitted the photographer to move in slowly on this toad and compose one photograph before it dived beneath the water's surface.

taken from a gray card. The advantage of using your palm is that you'll always have it with you. We know that our palms are approximately two-thirds of a stop lighter than medium, so we can easily determine the literal translation exposure from this reading. We meter our palms in the same light as the subject and select the shutter speed–aperture combination that registers as +0.7 in the camera's light meter display. This gives us the same exposure as we would get by metering off of a gray card.

The point is that you can meter any subject and determine a literal-translation exposure by recognizing tonalities and working

in stops. (On the far ends of the tonal scale, you need to make some adjustments.)

This technique of metering a substitute object in the same light as the subject is especially useful when photographing herps. When photographing basking tur-

tles, for example, you'll find that most of the time you're waiting for the turtles to appear in the right place. Then you need to react quickly when they do. Rather than metering off the turtles when they appear, it's more productive to meter off

Juvenile yellow-bellied racer *(Coluber constrictor mormon)* basking atop a river rock. *105mm macro lens, TTL flash, flash compensation dial set at -1.7, 50-speed film, 1/30 second, f/16, on tripod.*

Bill found this snake beneath a rock on a cool spring morning in central Washington. The cold snake was quite content to sit quietly in the sun for several exposures before it crawled off. Fill flash was used to reduce the shadows created by the bright sun. After several attempts at photographing this young racer "tasting" the air with its tongue, the photographer finally succeeded in capturing the moment on film.

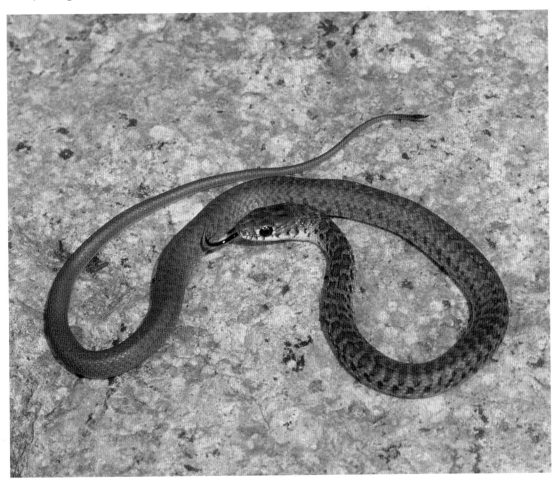

Costa Rican anole *(Anolis microtus)*. *105mm macro lens, TTL flash, camera compensation dial set at +0.3, 50-speed film, 1/250 second, f/16, handheld.*

The medium-green vegetation that fills much of the frame makes this a fairly easy exposure compensation. The +0.3 compensation slightly lightened the dark lizard.

another object—say a handy mat of one-stop-lighter-than-medium duckweed—and determine your exposure in advance. In this example, you'd meter the duckweed and add a stop of light (since it's lighter in tone). You'd also add another 0.3 stop to get a little more detail in the dark bodies of the turtles. As the light changes, you have to recheck the exposure from time to time so that you're always ready for the turtles.

Working in Automatic

When working in manual mode, you adjust exposure by changing shutter speed or lens aperture. But when working in automatic, as you change one, the camera changes the other to put you back to the exposure it assumes you need. The secret is to use the exposure compensation dial built into nearly every modern SLR. This allows you to tell the camera that you really do want to add or subtract from its readings.

Cloud forest anole *(Norops tropidolepsis)* on tree bark. *105mm macro lens, TTL flash, camera compensation dial set at +1, 50-speed film, 1/250 second, f/11, handheld.*

Using a lightweight close-up flash allows great freedom of movement. Electronic flash frees the user from many of the restraints of natural light, allowing quality photos to be made in difficult situations such as at night or in the deep shade of the Costa Rican rain forest that this little anole inhabited.

Some of the newer high-tech cameras have one-third stop shutter speeds, which can be handy when you want the fastest speed you can get. Instead of stopping down the lens a bit, you can leave the lens wide open and go to the next third stop speed.

We usually work in manual mode, but there are times, such as in changing light conditions, when automatic offers real advantages. As with any aspect of photography, once you understand it and become comfortable working with automatic and with using the compensation dial, you'll have another tool to use when the situation calls for it. Then you just dial in the appropriate compensation, and you're ready to go.

Male tailed frog (Ascaphus truei). 105mm macro lens, TTL flash, camera compensation dial set at +1, 50-speed film, 1/250 second, f/16, handheld.

This frog is at the dark end of the tonal scale, and the rock that it is sitting on is about one-third of a stop lighter than medium, compounding the problem and making a fairly large plus compensation necessary.

Albino Northwestern garter snake *(Thamnophis ordinoides)*. *200mm macro lens, 4T close-up lens, TTL flash, camera compensation dial set at -0.3, 1/250 second, f/16.*

The snake is toward the light end of the tonal scale, and the old bark surrounding it is much darker. For good detail in the light tones, a little minus exposure is in order.

Flash Photography

Flash

When we have a choice, we almost always prefer using natural light over flash. But many times, we can't rely on natural light alone to make the kind of photograph we want. When subjects are moving or the wind is blowing, we often don't have enough light to get the desired depth of field while maintaining a shutter speed fast enough to stop the motion. In these cases, we turn to compact electronic flash units.

The advantages of these flashes in field photography is that they're compact and self-contained, and they use readily available AA batteries. Many of the newer units allow you to adjust the flash output in a fill-flash mode controlled by a computer in the camera. This makes it easy to use the flash as a secondary light by adjusting the compensation dial on the flash.

TTL Flash and Manual Flash

Modern TTL flash has made it much easier to use flash in close-up work than it had been in the past. When the camera's flash meter senses that sufficient light has reached the film, it quenches the flash. Perhaps most importantly, since the light is being metered at the film plane, you don't have to worry about adjusting for any changes in lenses or accessories or for changes in position of the flash or the camera.

In contrast, manual flash systems put out a predetermined pulse of light in all situa-

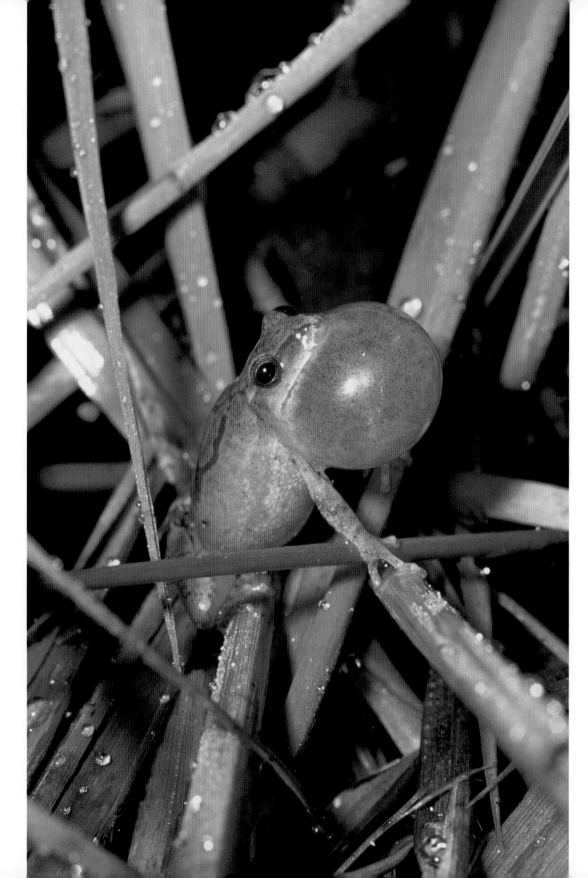

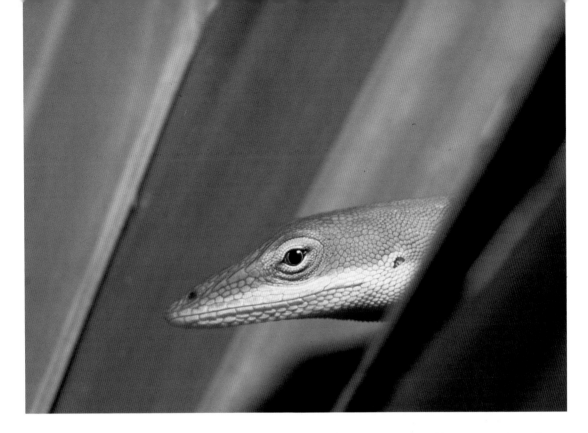

Green anole *(Anole carolinensis)* in saw palmetto. *105mm macro lens, 52mm extension tube, manual electronic flash, 25-speed film, 1/60 second, f/11–16, handheld.*

A green anole peeks out from behind the leaves of a saw palmetto. The use of a compact macro setup with a lightweight manual flash unit allowed great freedom of movement in stalking these small, agile lizards in the difficult tangle of a palmetto thicket.

tions. To use a manual flash unit for close-up work, you must first run a series of tests to determine the proper exposure for each lens-flash combination (and any accessories) you want to use. And you also have to adjust for subjects of different tonalities.

This isn't all that hard to do, but in practice, it limits you to fewer options because

Spring peeper *(Pseudacris crucifer)* singing on a rainy night. *105mm macro lens, manual electronic flash, 25-speed film, 1/60 second, f/11, handheld.*

During a brief respite in an April downpour, a male spring peeper proclaims its ardor from a vernal pool.

you have to remember all the correct settings when you're in the field. This is the single biggest disadvantage of using cameras without TTL flash, and it's why we recommend cameras with TTL flash capabilities. The versatility and ease of use of the TTL flash make it a powerful tool in field photography.

Full Flash
In full, or total, flash, the flash provides all the light for the photograph. Focal plane shutter cameras—which most 35mm cameras are—allow you to synchronize the flash up to a certain shutter speed. If you use slower shutter speeds, you're fine. If you use faster shutter speeds, you'll expose

Gray treefrog and moth flies on sliding glass door. *105mm macro lens, manual electronic flash, 50-speed film, 1/250 second, f/16, handheld.*

Every evening one summer, this treefrog stalked insects on Larry's sliding glass door. The photograph was made with a small TTL flash in manual mode, allowing a pretested exposure to be used in this difficult photographic situation.

only a portion of the film. The flash synchronization speed for most current cameras is 1/250 of a second.

For full flash exposures, set the camera to manual mode at its highest flash sync speed. Full flash allows the camera to be handheld, since the duration of the flash in effect becomes the shutter speed. Thus, even though the shutter remains open for 1/250 of a second at the camera's flash syn-

Pickerel frog *(Rana palustris)*. *105mm macro lens, manual electronic flash, 25-speed film, 1/60 second, f/11–16, handheld.*

Pickerel frogs inhabit marshy edges of ponds, streams, and bogs. A pretested exposure for the lens, flash, and film combination was used for this medium subject on a medium background.

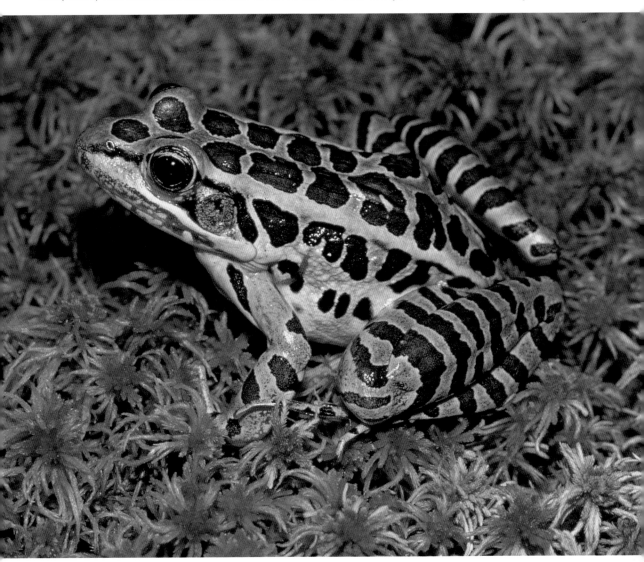

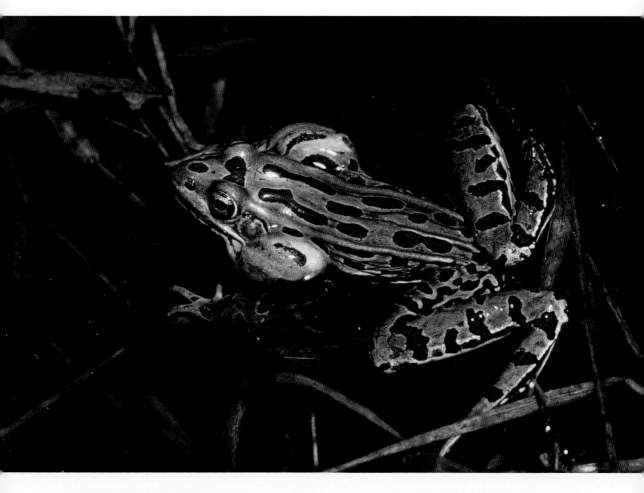

Northern leopard frog *(Rana pipiens)* calling. *105mm macro lens, manual flash, 25-speed film, 1/60 second, f/8–11, handheld.*

At one time, northern leopard frogs were among the most common species in much of the eastern United States. However, populations have drastically dropped off since the 1970s. The lack of reflective surfaces around this large medium-tone frog required the exposure to be increased by +1 stop.

chronization speed, the burst of light from the flash lasts at most 1/1,000 of a second, and with larger TTL flash units used close up, flash duration may be only 1/5,000 of a second. This is fast enough to freeze most motion. For example, you can stop the vibrating vocal sac of a singing frog or the flicking tongue of a snake.

Full flash also allows you to hold the camera by hand in many situations in which you would otherwise be unable to. It's especially useful when using a short telephoto lens, such as a 105mm. Using that combination with total flash, you can photograph in nooks and crannies and other places where you can't maneuver a tripod-mounted cam-

era. We use tripods whenever we can, but a handheld camera with full flash works magic in certain situations. Also, the flash allows you to use both a fast effective shutter speed and a small aperture.

We also use a handheld flash setup as a sort of visual notebook. Since it's easy and portable, it's a great way to quickly record discoveries and to photograph behavior. The results are more "clinical" looking, but when you happen upon unusual behavior or a rare or unknown species, the ability to capture a clear, clinical photograph greatly improves your chances of identifying and documenting the event.

Fill Flash

A second use of flash is fill flash. With fill flash, the ambient light is the main light source, and the flash provides supplementary light. Fill flash is often used to open up shadows in harsh light, to add a highlight to an eye in dull overcast light, or to add a little backlighting. The fill flash is always weaker than the existing daylight. We most often set the flash to -1.7 or -2. As always, it pays to experiment with other combinations to learn how they affect your photographs.

Fill flash does not provide the action-stopping capability that total flash does, because it only supplements the natural light. However, in many situations, it can be used to greatly enhance the quality of natural light photographs.

Where Do You Put the Flash?

The most useful and versatile lighting for single-light close-up photography is called *high basic*. In high basic, the flash sits over the camera about 30 degrees above the axis of the lens. The high-basic position provides nice, open lighting for most subjects.

You need to use a flash cord to get the flash off the camera's hot shoe. Use your camera manufacturer's auxiliary flash cord to maintain full TTL control and to avoid the problems that sometimes arise with cheaper aftermarket brands.

A flash bracket is an almost indispensable accessory, serving as a mechanical hand to hold the flash in the position you want. If possible, choose a bracket that enables you to rotate the flash or the camera and thus keep the same lighting as you change from a horizontal to a vertical composition.

A rotating collar, such as those typically found on 200mm macro lenses and longer telephoto and zoom lenses, makes it easy to change from horizontal to vertical compositions. With the flash bracket mounted to the lens collar, you can quickly rotate the flash so that the light position remains the same as you switch between horizontal and vertical. Flash brackets that mount to the camera bottom require more gymnastics to make the change from horizontal to vertical. It's still possible, but it's slower and can be frustrating if your subject hops or crawls away while you're adjusting the flash.

At times, you'll want to use other flash positions. Often, the subject will be under a log or rock or in a cavity, and you'll have to maneuver the light to compensate. An example of this is Larry's picture of a spring peeper (*Pseudacris crucifer*) in a rolled-up milkweed leaf (see page 8). By mounting the camera on a tripod, framing the subject, and holding the flash directly on the lens, he was able to direct light into the cavity and illuminate the frog in its hiding place.

Another lighting technique you'll want to use is sidelighting. It's especially useful when photographing subjects that are underwater. We recently used flash in a sidelighting position to photograph a foothill yellow-legged frog (*Rana boylii*) sitting at the bottom of a rocky stream. By angling the flash, we were able to light the frog while avoiding glare from the water's surface. In the same composition made with natural light, skylight reflecting off the water obscured the pattern and texture of the frog. Both techniques

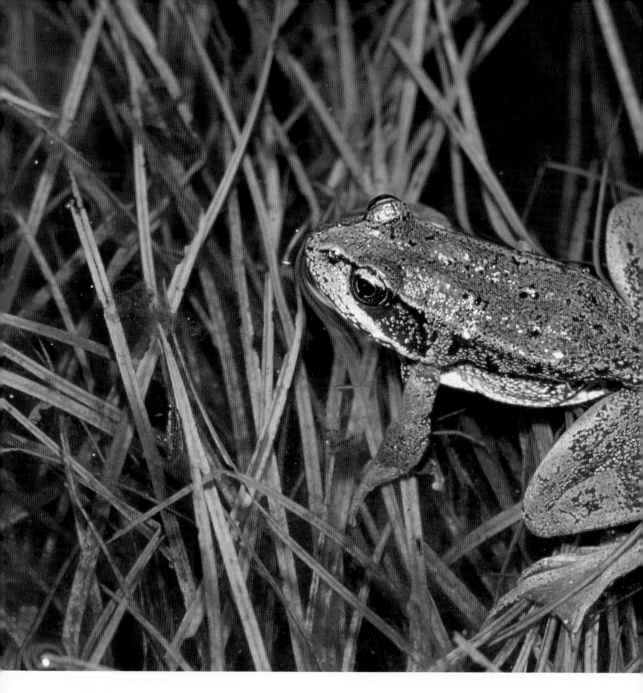

resulted in interesting photographs, but if you want details below the water's surface, the flash picture is preferred.

Support for Flash Setups

For smaller subjects or subjects that will stay put, we usually mount the camera-flash combination on a tripod. Say, for example, you're photographing a singing frog that is likely to remain still. Using a tripod (even with flash) helps ensure that every photograph is perfectly focused and properly framed. And since you don't have to hold the camera in place, it makes it easier on you while you wait for the perfect pose.

Northern red-legged frog *(Rana aurora aurora)* floating among sedges. *105mm macro lens, TTL flash, camera compensation dial set at +0.7, 50-speed film, 1/250 second, f/11, handheld.*

Red-legged frogs are usually quite wary. A handheld flash setup was used to move in slowly and fire off several frames before the frog disappeared below the surface into the sedges.

done. Water and grit can wreak havoc on threads and locking mechanisms. One trick is to put the legs in heavy-duty garbage bags and secure them with rubber bands to keep the legs dry.

Of course, many times you won't be able to maneuver a tripod into position, and you'll have to rely on a handheld setup. You can make things easier by using your body as a tripod in these situations. First, preset the magnification you need for the framing you're trying to achieve. Then press your elbows firmly against your chest and slowly move back and forth until you hit focus. Sometimes you can get greater stability by sitting or kneeling and resting your elbows on your knees or thighs (see page 24).

Flash Theory, or Inverse Square Law

Once you have a basic understanding of how light behaves, flash photography begins to make sense. As a short burst of light leaves the flash, it spreads outward. As the light spreads to cover a wider area, its power to illuminate any given area diminishes. That is, the farther away the flash, the wider the area the light covers, but the dimmer it becomes. We commonly say that the light "falls off."

This movement of light happens in a predictable pattern described by the inverse square law, which simply states that light will fall off to the square of the distance it travels. So if a flash illuminates a certain

Tripods also come in handy when photographing in ponds. Whether you choose to plunge in with your expensive new tripod is up to you. But if you own an older tripod, you might consider making it your pond tripod (see page 25). In any case, if you take a tripod into water, either take care to keep it dry or clean and lubricate it when you're

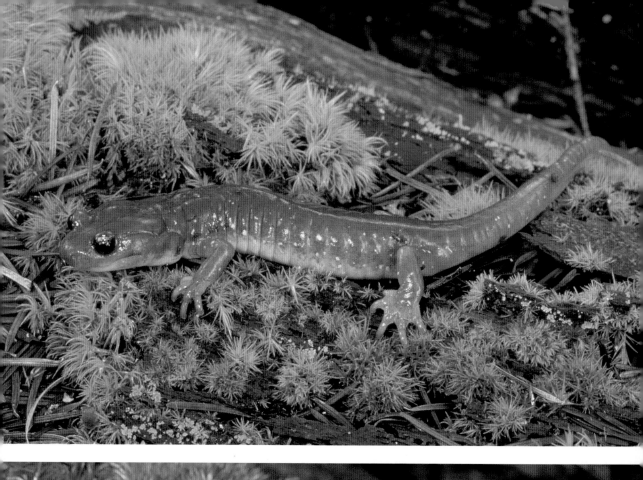
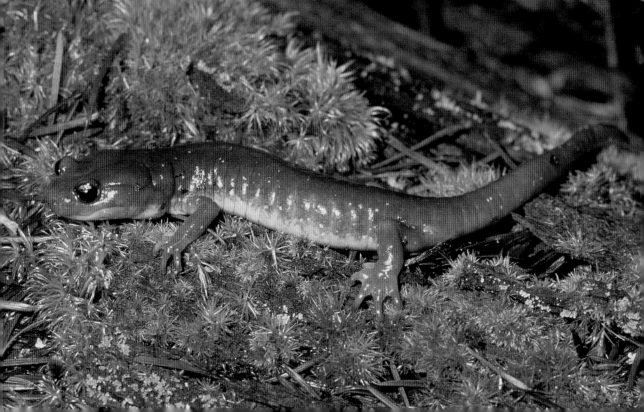

area 1 foot away, at 2 feet, that same amount of illumination will spread out over four times the area.

At double the distance, you can also think of the light as being two stops less bright. If you double the distance again, moving the light to 4 feet, you weaken the light by another two stops, making the light four stops less at 4 feet than it was at 1. So the farther away you place the flash from the subject, the less intense the light will be as it reflects off the subject to record its image on film. Conversely, the closer the flash is to the subject, the more intense the light.

Exposure with TTL Total Flash

Keep in mind that, as mentioned earlier, most modern cameras have a separate flash meter and automatically use that meter when in flash mode. So to make the most of TTL flash, you need to understand how that meter sees the scenes you're photographing.

Some older TTL cameras have center-bottom-weighted meter patterns. (Of course, if you have a horizontal center-bottom-weighted pattern and turn the camera vertically, you'll have either a center-right- or a center-left-weighted pattern.) Some newer cameras have matrixlike meters that break your composition into five segments, analyze the patterns, and compute an expo-

Arboreal salamander *(Aneides lugubris)* climbing on a log on the forest floor. *Top: 105mm macro lens, TTL flash, camera compensation dial set at +0.7, 50-speed film, 1/250 second, f/11, on tripod. Bottom: 105mm macro lens, TTL flash, camera compensation dial set at 0, flash compensation dial set at -1.7, 50-speed film, 1/30 second, f/16, on tripod.*

It's a personal choice which photograph is more aesthetically pleasing. The upper photograph was made using full flash; the lower one with fill flash to put a highlight in the eye.

sure. It's important to keep in mind how the TTL flash meter reads the scene as you try to decide whether, and how, to adjust the exposure in any given situation.

If you're photographing a subject that's close to medium tonality with a background that's also close to medium, little, if any, compensation should be needed. In other situations, you have to compensate for lighter or darker tonalities by changing the exposure from the one the camera suggests.

New cameras have compensation dials that allow you to dial in more or less exposure. If your camera has TTL flash but doesn't have a compensation dial, you can reach the same end by adjusting the camera's ISO dial. (If your flash also has a compensation dial, leave that set at zero—no compensation—and use the compensation dial on the camera itself.)

Let's look at how to adjust the exposure in some common situations using Nikon 8008s camera bodies. If you try photographing a medium-tone Fowler's toad *(Bufo fowleri)* on light sand (one stop brighter than medium) with no compensation, your pictures will always be one stop too dark. The camera reads the center and bottom of the frame and makes all that bright sand a medium tone and thus drops the medium-tone toad to dark. (Keep in mind that flash meters are designed to render whatever they're pointed at as a medium tone.) It's up to you to recognize the situation and set your camera compensation dial to +1.

Next, consider a lighter-than-medium subject against a darker background—say a spring peeper clinging to a vine against a distant background. Reading the dark background, the flash meter tells the flash to put out more light to make the background medium tone, and you end up with an overexposed peeper. Here, you need to dial in a correction of between -0.3 and -1 stop.

The basics of exposure compensation aren't difficult to master, but you need to

give the composition some time and thought. There are many combinations and situations, and it can be mystifying at first. Our advice is to keep good notes when confronted with a situation you don't understand. Keep a notebook handy, and whenever you're doing something you haven't done before, write down the subject and the compensation, and bracket the exposure a third of a stop in each direction. With a small, light subject, such as an albino snake, against a dark background, you might dial in -0.3 and -0.7 and record that. Once your film is processed, examine the photographs to see what worked—and what didn't. Soon, you'll have a good idea of what to do in most situations.

Total Flash without TTL–Inverse Square Flash

If your camera doesn't have TTL flash capability, you can still get good close-ups using inverse square flash. This technique allows you to use a small manual flash unit, along with a short telephoto lens and some sort of an extension-based system to allow you to focus closer. The flash always fires at its maximal output, and you control the amount of light reaching the film by changing the lens aperture. There's no metering involved.

Inverse square flash is based on the following principle: as light is lost from the extension of the lens (as the camera is moved closer to the subject), the intensity

Black salamander *(Aneides flavipunctatus)* on mossy log. *Opposite page: 105mm macro lens, TTL flash, flash camera compensation dial set at -1.7, 50-speed film, 1 second, f/16, on tripod. Above: 105mm macro lens, 50-speed film, 1 second, f/16, on tripod.*

Both photographs work, but the one on the opposite page—where fill flash was used to open up shadows in the moss and alongside the salamander—is brighter and has a nice open feel to it.

of the light increases (as the flash is moved closer to the subject). In other words, as you move the camera closer to the subject, you lose light, but as you move the flash closer with the camera, you also gain light. By the inverse square law, one cancels the other out.

Either system works fine, so it's easiest to pick one and stick with it. If you have TTL flash, use it. If not, you can get excellent photographs using inverse square flash.

A key element of an inverse square flash rig is a short telephoto lens, in the range of a 105 macro or a straight 105 used with extension. You also need a flash (a manual one is ideal) that is powerful enough to expose at f/16 with ISO 50 film using a lens of the focal length you've chosen. With anything weaker, you'll have to use wider apertures than you'd prefer when photographing darker compositions. In practice,

Tropical treefrog *(Smilisca phaeota). Below: 105mm macro lens, 27.5mm extension tube, TTL flash, camera compensation dial set at +0.3, handheld. Opposite page: plus manual slave flash.*

In the photo below, a single flash at a 30-degree angle over the camera lens gave good overall illumination but failed to put a highlight in the eye because of the frog's protruding brow ridge. In the second photo, a weaker second flash was added to highlight the eye and provide a bit of fill to the shadows.

this means that you need a flash with a guide number of at least 40 for 50-speed film; higher would be better. Pick a film in the 50- to 100-speed range. Always keep the flash in the same position relative to the front end of the lens. We recommend keeping the flash in the high-basic position for most subjects.

Inverse square flash doesn't work as well with macro zooms, internal focus lenses, or close-up lenses. Since these don't rely on extension to reach closer focus, you don't

lose light as you move in. Every time you change the working distance and image size, you have to change the aperture of your lens—a real inconvenience.

After you've assembled your gear, you need to run some tests with it. First, find a medium-tone subject and photograph it on a medium-tone background, say a photographic gray card. This initial test gives you the base exposure settings for medium-tone subjects and for subjects one stop darker or one stop lighter than medium.

You should also photograph your test subject from various distances. For example, shoot from the distance you'd have to be from a spring peeper to have it fill the frame; then move back to the distance from which you could fill the frame with an American toad (*Bufo americanus*); finally, shoot from bullfrog (*Rana catesbeiana*) distance. This will tell you if you need to close down or open up a little as you move in for smaller subjects or move out for larger subjects.

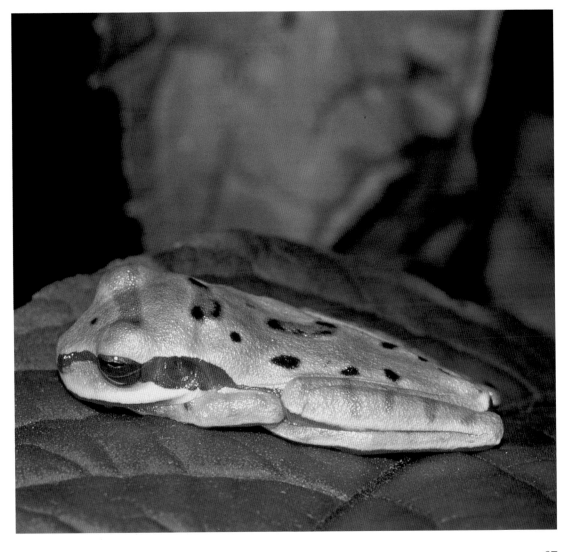

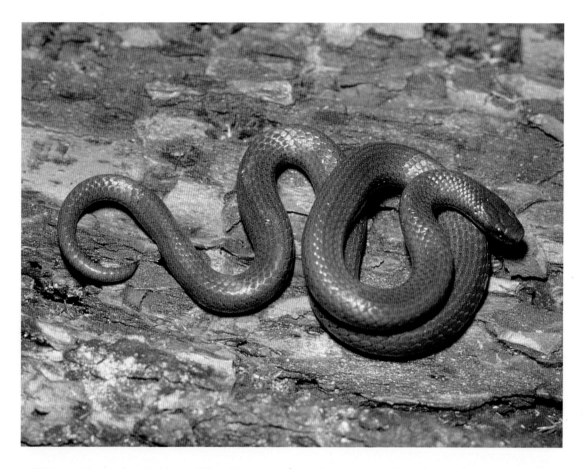

We recommend starting at f/8 and working all the way down to f/22, shooting each sequence at half-stop increments. Take careful notes on how you expose each frame so that you can analyze your results. It helps to make a chart to use until you memorize the exposure settings.

If your subjects are out of that three-stop tonal range, you need to manually adjust your lens aperture to compensate and get a good literal-translation exposure on the film.

If the subject is dark, such as a green frog (*Rana clamitans*) sitting in the water with nothing around it to reflect light, you need to open up one-half stop or even a full stop. Keep notes and scrutinize your results; you'll soon be able to read each situation with a more confident eye.

In the case of the green frog, let's assume that your normal exposure was f/16. The first time you photograph a dark frog in a situation like this, you'd expose one frame at f/16, one opened up a half stop to between f/11 and f/16, and finally one at f/11.

Working in the other direction, let's say you happen to be photographing a Fowler's toad on light beach sand, which is very reflective. Here, you have to close down to compensate for the brightness of the scene. Simply bracket down by half stops from f/16 to f/22.

Again, when you get the photographs back, look over the sequence and decide which setting has given you the exposure you want. Then you'll know exactly what to do next time.

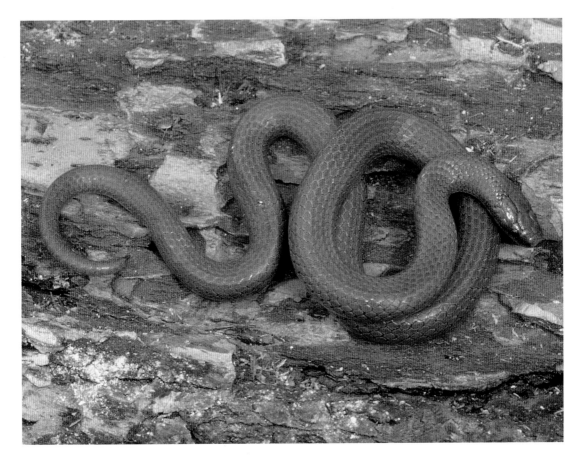

Sharp-tailed snake *(Contia tenuis)* on pine log. *Opposite page: 105mm macro lens, TTL flash, camera compensation dial set at +0.7, 50-speed film, 1/250 second, f/11, on tripod. Above: 105mm macro lens, TTL flash, camera compensation dial set at 0, flash exposure compensation dial set at -1.7, 50-speed film, 1/30 second, f/16, on tripod.*

The photo on the opposite page, taken with full flash, is an excellent "clinical" image of the snake. The image above, made using fill flash, has softer, more even light. Had the snake been moving, the fill-flash photograph would not have been possible.

Why Does the Background Go Black?

Why do we get black backgrounds in photographs made using a flash? The answer lies in the inverse square law (see the earlier discussion), and it's easily understood if you think of distance in terms of f-stops.

Let's say there's a medium-tone Pacific treefrog sitting on a medium green leaf 11 inches from our flash-camera combination.

Both background and subject are the same distance from the flash, and both will be correctly exposed at the base exposure of f/16. Now, if we move the background from 11 inches to 16 inches, we've lost one stop of light to the inverse square law. As a result, the medium background will appear one stop darker, and the subject, the frog, will be properly exposed. If we move the

69

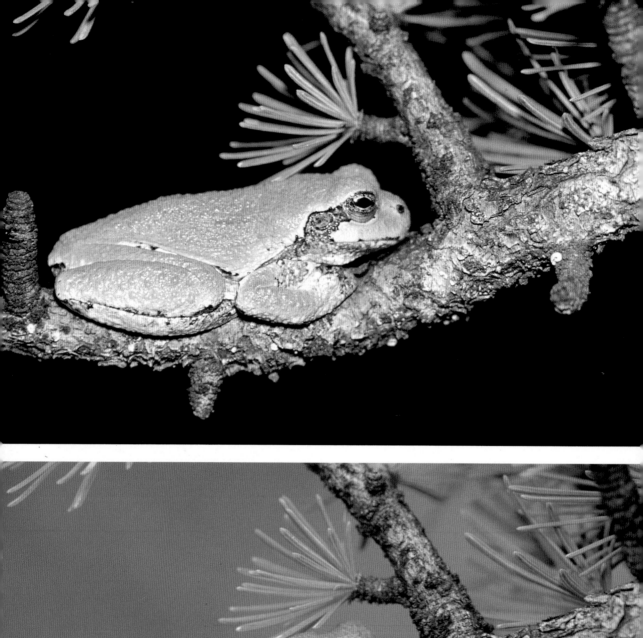
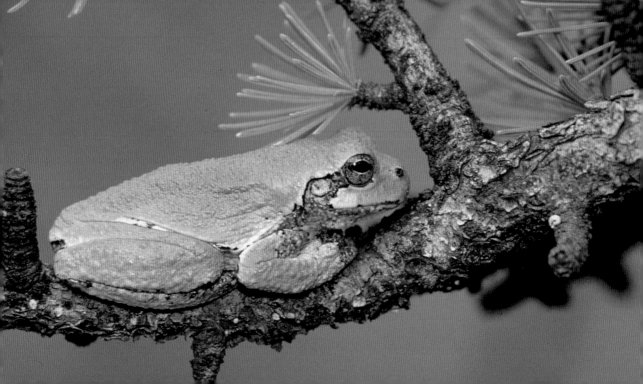

With camera firmly attached to a tripod, Larry uses fill flash to soften the shadows of a harsh desert sun.

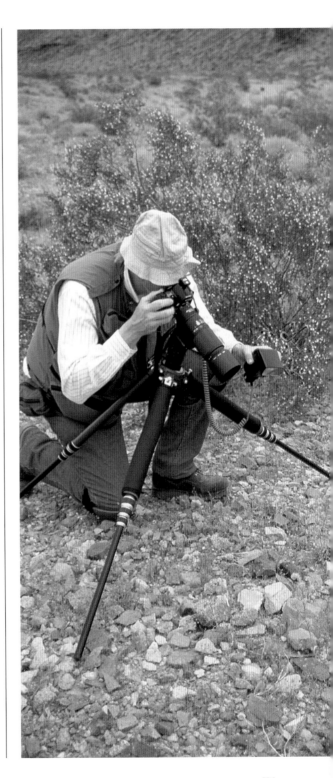

background to 22 inches—double the starting distance—we lose two stops of light to the inverse square law, and the background drops from medium to very dark, right on the edge of black.

Background tonalities work in stops and can be predicted by using the inverse square law. If the medium background is two stops farther from the flash than the subject, it is guaranteed that the background will turn out very dark. If it's more than two stops farther away, it's going to be jet black.

If you've got a background that's 12 inches or so behind the subject and the flash stays with the camera, you'll get better-lit backgrounds with a 105mm than you would with a 50mm lens. A 200mm would give you even better lighting, since the increased working distance turns the inverse square law to your favor.

Gray treefrog on branch. *Top: 200mm macro lens, TTL flash, camera compensation dial set at +0.3, 50-speed film, 1/250 second, f/16, on tripod. Bottom: 200mm macro lens, TTL flash, camera compensation dial set at 0, flash compensation dial set at -2, 50-speed film, 1/8th second, f/11, on tripod.*

If the situation permits, fill flash can be wonderful. In the top photo, all natural light is blocked from the film by the high (1/250 of a second) synchronization speed. Although the subject is adequately lit, the background is rendered solid black. The bottom photograph was metered as if a straight natural light exposure were being made. A weak fill flash kept a highlight in the eye and added a little sparkle to the skin.

Exposure Metering for Fill-Flash Situations

With fill flash, we're really making a natural light exposure and adding a touch of flash to lighten up shadows, add a little sparkle, or add highlights in dull light.

Say you want to photograph a rubber boa (*Charina bottae*) resting on a gravelly river-bank in dull, overcast light. Since the boa's sitting quietly, you can work off a tripod and make longer exposures at smaller apertures to get the depth of field you need. Once you set up your gear, move it into place, and find a composition you like, take a meter reading just as you would if you were going to expose the scene by natural light alone.

Bullfrog *(Rana catesbeiana). 200mm macro lens, 1.4X multiplier, TTL electronic flash, flash compensation dial set at -2, 50-speed film, 1/4 second, f/11, on tripod.*

The main lighting in this photograph is soft natural backlight supplemented with fill flash to add a highlight to the eye. Exposure was determined by spot metering the medium-tone areas on the frog's back.

of your hand and making your previously established exposure compensation. (One secret to successful palm reading is to make sure that your palm is in the same light as your subject. Be careful that you're not shading your hand as you make the reading or holding it at an angle where it reflects more or less light than the subject. Long arms help.)

Adding the fill flash is easy with TTL flashes that allow you to program the strength of the flash. You should experiment with the strength of the flash output, but we recommend starting somewhere between -1.7 and -2 stops. With the newer programmable TTL flashes, you program the desired flash strength by pressing the appropriate button on the flash until the LED display on the flash is set where you want it. Now you're ready to take the photograph.

Some TTL flashes have a rear-curtain synchronization mode, which offers real benefits in fill flash, especially at long shutter speeds. Sometimes the subject twitches or blinks in response to the flash. If that twitch happens at the beginning of a lengthy exposure, you end up with a blurred image. With rear-curtain synchronization, the flash fires at the end of the exposure, so the shutter is closed before any movement takes place.

Fill flash won't work, nor will it be needed, in every situation. But in the right situations, fill flash is a powerful tool and can be used to make stunning photographs.

In this example, your subject—the snake—is close to a medium tone, and the gravel background is a bit lighter than medium. You could take a spot meter reading directly off the snake and use that for a literal-translation exposure. You could also get to a literal-translation exposure by taking a substitute meter reading off the palm

Eastern box turtle *(Terrapene carolina carolina)*. *200mm ED macro lens, 81A warming filter, TTL electronic flash, flash compensation dial set at -1.7, 100-speed film, 1/8 second, f/11, on tripod.*

In the soft shade of a late afternoon in Michigan, an eastern box turtle views its surroundings. A sturdy tripod provided crisp detail, fill flash added a highlight to the eye, and a warming filter helped remove the blue cast of open shade.

Snapping turtle *(Chelydra serpentina)*. *75–150mm zoom lens, TTL flash, flash compensation dial set at -1.7, 50-speed film, 1/8 second, f/11, on tripod.*

Female snapping turtles live most of their lives in ponds, rivers, or marshes, but they lay their eggs in nests they dig in dry, sandy areas. A bit of fill flash opened up the shadows created by the protruding shell above the turtle's head.

Working with a Second Light Source

Sometimes a second flash can be used to enhance the lighting. Small, simple-to-use slave flash units work extremely well. They don't need to be attached to the camera. The slave flash fires when its sensor detects the light from the primary flash. The Morris Midi works well in the field, even in bright sunlight. It's compact and runs on AA batteries. The trick in combining a manual flash with a TTL flash is to make sure that the secondary manual flash is weaker, so that it just adds highlights and doesn't affect the exposure. In effect, you're adding fill flash to a flash exposure as opposed to a natural light exposure.

A second light is indispensable when you're trying to put a highlight in the eye of a herp with protruding eyebrow ridges. In close-ups, a protruding brow ridge prevents high-basic light from reaching the eye, resulting in photographs of herps with dull, black eyes. The slave flash can be angled to catch the eye, creating images of herps with bright, engaging eyes. Slave flash can also be used for backlighting, as well as for lighting backgrounds.

A Larry West
and Bill Leonard
Portfolio

Gopher Snake *(Pituophis catenifer). 105mm macro lens, 50-speed film, 1/30 second, f/8, on tripod.* LARRY WEST

At first glance, a gopher snake encountered among rocks or brush can look startlingly like a rattlesnake. The resemblance goes beyond size and the patterns of blotches on their bodies. Gopher snakes encourage the confusion by spreading their jaws wide, vibrating their tails, and performing a really good rattlesnake impersonation.

We stumbled across, and got a good start from, this gopher snake while we were poking around a rocky area in southern Nevada. (Being startled is OK. It's better to keep a healthy panic reflex than to become too cavalier about venomous snakes.) Bill kept an eye on the snake while Larry went back to the car to get the camera equipment. We spent about half an hour photographing it, keeping our distance so as to disturb it as little as possible. It finally crawled up a steep rock face, where Larry recorded this portrait.

These big, pudgy lizards certainly live up to their species name—*obesus.* At home in the Southwest, chuckwallas eat the blossoms, leaves, and fruit of desert plants. Creosote bush is the mainstay of their diet, and wherever you find stands of creosote bush near rocky hillsides or outcrops, you're likely to find chuckwallas. They tend to stay tucked into the safety of rocks until long after smaller lizards are out and about. They arise by midmorning, bask awhile, then forage on nearby vegetation.

We found this chuckwalla in just such an area one sunny morning, still in the rocky crevice where it had spent the night. We set up our gear a short distance away, then waited until it emerged to sun. We spent a couple of hours with it that morning—mostly just watching. The lizard never went far from the security of its crevice, but from time to time it came out to bask, and we were both able to get a nice series of images.

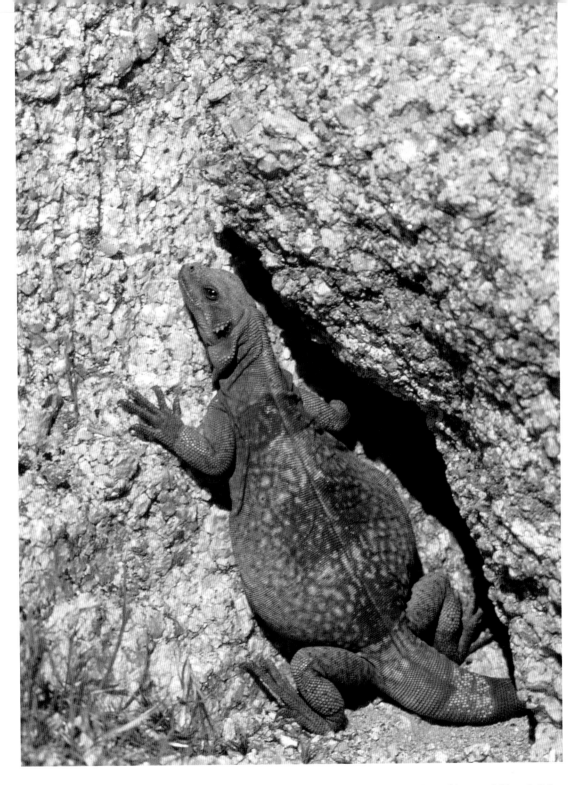

Chuckwalla *(Sauromalus obesus). 200mm macro lens with 1.4X multiplier, 50-speed film, 1/30 second, f/8, on tripod.* LARRY WEST

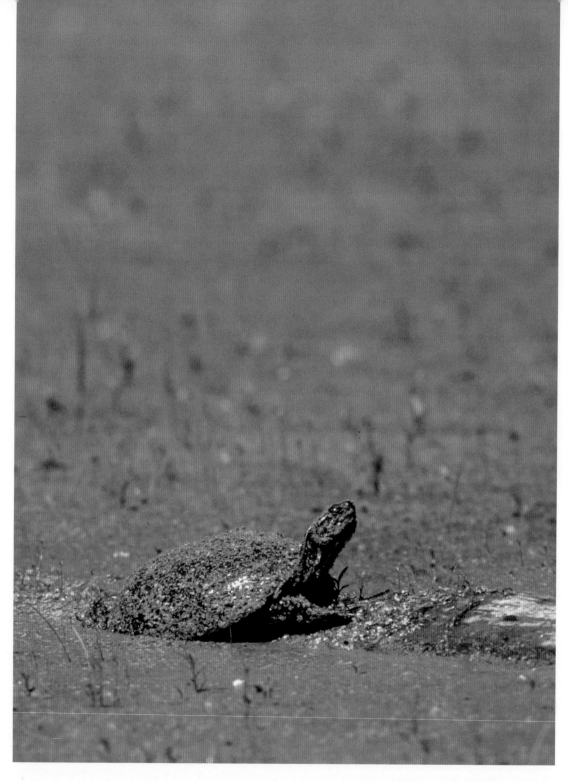

Painted turtle *(Chrysemys picta)*, basking. *400mm lens with 2X multiplier, 100-speed film, 1/125 second, f/11, on tripod.* LARRY WEST

Marine toad *(Bufo marinus)*. *105mm lens, handheld with TTL electronic flash, camera compensation dial set at +0.3, 50-speed film, 1/250 second, f/11.* LARRY WEST

Near Larry's house there's a duckweed-covered pond that's home to three species of turtles. In May, when the days still hold the coolness of spring, the turtles spend much time sunning on logs, and he spends a lot of time sitting on the bank photographing them. You can use a portable blind for this kind of photography, but Larry prefers to just sit in a folding chair.

Like much of wildlife photography, time spent with the turtles is a time of quiet celebration. It's a time to slow down and relax, your meditations punctuated from time to time by the sudden excitement of a turtle breaking through a green carpet of duckweed and hauling itself up onto an old log.

Larry uses the long focal length lens (800mm) because it covers a much bigger area of pond; a shorter lens doesn't have that reach.

This species of large lowland toad ranges from Texas to Brazil. Marine toads are versatile animals; they'll eat just about anything from insects to smaller toads. They also eat dog and cat food and all sorts of kitchen scraps, so they're common around human habitation. Larry found this toad in the backyard of a Costa Rican lodge.

Giants of the toad world, they're incredible creatures; this one was more than a handful of toad. Yet in spite of their size, these nocturnal toads are hard to find by day, when they hide among roots and under logs. They come out at dusk to forage, which presents would-be photographers with a challenge in lighting. Larry made this image with the help of a handheld flash camera setup. A companion held a flashlight on the subject to provide light to focus by.

Red diamond rattlesnake *(Crotalus ruber).*
200mm macro lens, 50-speed film, 1/30 sec-
ond, f/8, on tripod. LARRY WEST

Red diamond rattlesnakes live in the desert, thorn scrub, and open chaparral of Baja California. They range north into southern California, where Larry and his friend Mike Rigsby happened on this snake while exploring a desert park.

These snakes are more richly colored relatives of the western diamondback. They're also considered less aggressive than their cousins. This snake was lying near some bushes when Larry and Mike first noticed it. In the hour or so spent photographing it, it never coiled or threatened, but merely climbed waist high into a mesquite bush, where it kept a watchful eye. The snake maintained its composure in part because they were careful not to threaten it by pushing its limits. The 200mm lenses allowed Larry and Mike to work at a distance that felt safe for both them and the snake.

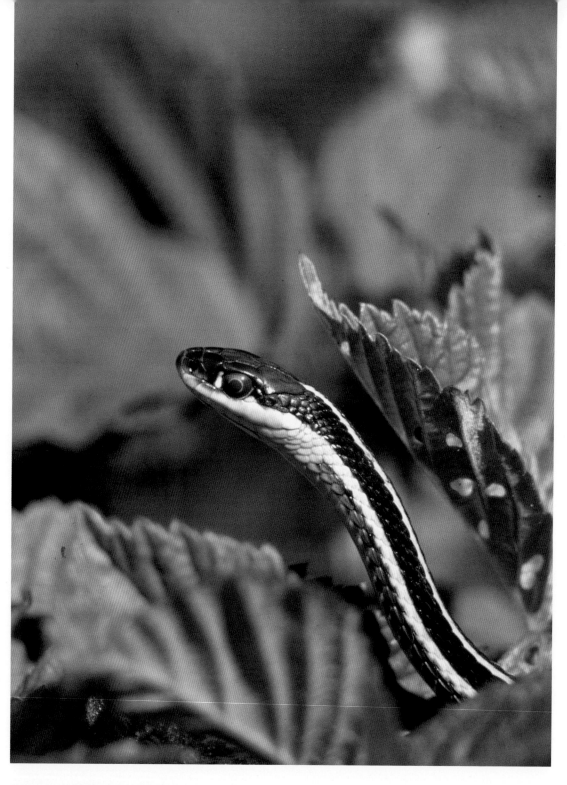

Eastern garter snake *(Thamnophis sirtalis sirtalis)*. *200mm macro lens, 50-speed film, 1/15 second, f/11, on tripod.* LARRY WEST

Common garter snakes live up to their name: they're the most common snake across much of North America. This eastern subspecies is certainly the most common snake where Larry lives. They live along the edges of ponds and in moist woodlands, where they hunt frogs, toads, leeches, small mammals, and even fish. But they're also found in backyards and urban areas, where earthworms and slugs are the mainstays of their diet.

If you look carefully, you can sometimes see garter snakes basking or hunting up in bushes. Larry found this snake high among a tangled blackberry patch that was growing at the edge of an old field. He had been stalking dragonflies, and the same equipment used to photograph them worked just as well for this snake portrait.

Larry spent a good deal of time last summer in a little pond behind his house photographing green frogs, where he made this portrait. The picture tells more of a story than is obvious at first glance. Above one eye, there's a biting midge, or "punkie," caught in midair by the light of the flash.

It's amazing how much herps are bothered by biting insects; there are even mosquito species that specialize only in herps. On this particular day, there were sometimes 10 midges (of the family Ceratopogonidae) at a time drawing blood from a single frog.

Green frogs live around most inland waters. If they're not already, they may soon be the most common true frog in North America. They and bullfrogs seem to be holding their own, whereas most other native frogs are declining in numbers.

Green frog *(Rana clamitans). 200mm macro lens with electronic flash, camera compensation dial set at +0.3, 100-speed film, 1/250 second, f/16, on tripod.* LARRY WEST

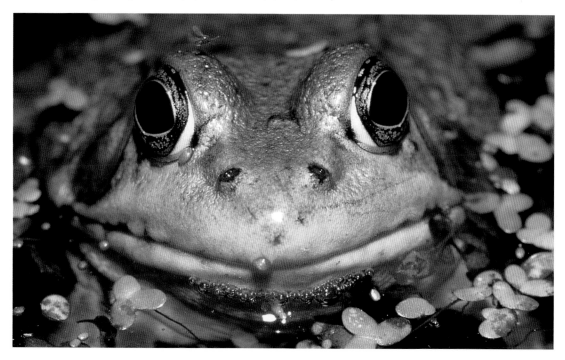

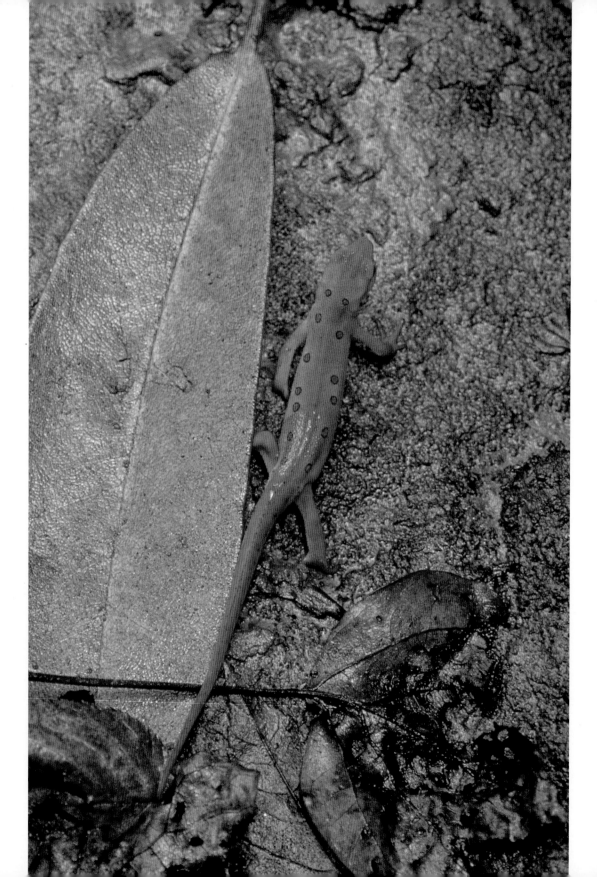

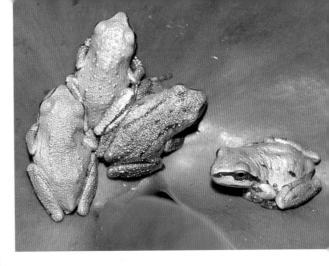

Newly metamorphosed Pacific treefrogs
(Hyla regilla) on yellow pond lily leaf.
*105mm macro lens with TTL electronic flash,
camera compensation dial set at +0.7, 50-
speed film, 1/250 second, f/11, handheld.*
BILL LEONARD

M ost newts have a terrestrial stage, during which they are called efts. After starting life in the water, newt larvae transform into efts and leave the water to live on land for up to three years. There, they eat worms, leeches, insects, and tiny mollusks before returning to the water and transforming into adults.

Newts produce toxic skin secretions, so few things eat them. Thus protected from predators, newts venture out in midday on warm, rainy days. At times, you can find dozens as you walk through the woods, especially in the southern part of their range. That's how a workshop group that Larry was leading in West Virginia happened across this newt resting in a damp spot along a stream. It was content to stay put long enough for several people to photograph it.

I t's amazing how often photographers go into the field to photograph a particular subject, only to find their attention shifting to something else as another opportunity presents itself. On an early July morning, Bill and his son Nick visited a lowland marsh near their home in western Washington to photograph garter snakes. When they arrived, they were astounded by the presence of thousands of young Pacific treefrogs covering every leaf, stem, and branch around their breeding ponds.

This group of newly metamorphosed frogs was huddled on a yellow pond lily leaf, basking in the early sun. Although frogs are ectothermic, or cold-blooded, they're able to regulate their body temperature through their behavior. They adjust their body temperature by moving in and out of the water and between shaded and sunny places.

The presence of huge numbers of young frogs attracts hungry garter snakes to the pond where this photograph was made. In midsummer, small treefrogs constitute a large portion of the diet of Puget Sound garter snakes, which are found swimming in the water and climbing low bushes around the pond.

Red-spotted newt in red eft stage
*(Notophthalmus viridescens viridescens).
200mm macro lens, 50-speed film, 1 second,
f/11, on tripod.* LARRY WEST

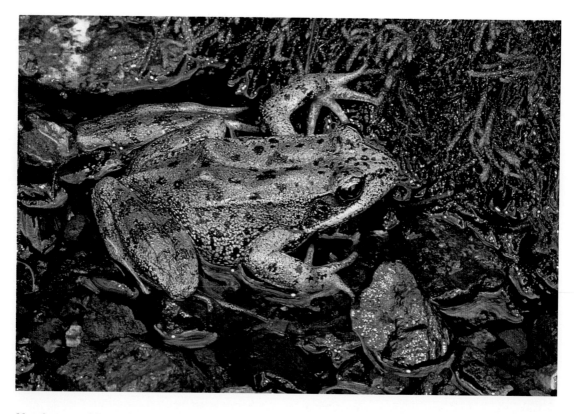

Northern red-legged frog *(Rana aurora aurora)* on stream edge. *105mm lens, 50-speed film, 2 seconds, f/16, on tripod.* BILL LEONARD

Northern red-legged frogs live in cool, damp Pacific Northwest woodlands. Bill found this frog at the edge of a small, heavily shaded stream in western Washington. In the dim light, he set his camera on a tripod to maximize depth of field by using a small aperture with a long shutter speed. He could have used flash but wanted to record the feeling of the diffuse natural light beneath the forest canopy.

The males of this species lack the large vocal sacs found on many other true frogs.

Their call consists of a series of weak clucking notes. These frogs breed in winter in wetlands and along the edges of ponds and lakes, then disperse into the surrounding forests, where they're often found along creeks and streams.

Like many frog species, red-legged frogs have declined over much of their range. They're still common in many areas in Washington, but they've experienced significant declines in Oregon and California.

The Pacific giant salamander is the largest terrestrial salamander in the world, and one of the most beautiful. This finely patterned juvenile was found swimming in a cold, clear, rocky-bottomed Oregon stream. Pacific giant salamanders spend several years in streams as aquatic larvae before metamorphosing into terrestrial adults. Larvae can be found in many northwestern streams, but transformed adults, such as this one, are rarely seen in the wild.

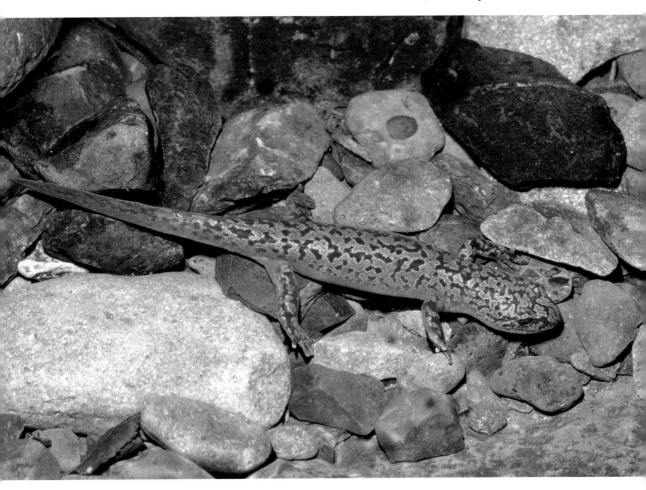

Pacific giant salamander *(Dicamptodon tenebrosus)*. *105mm macro lens, TTL electronic flash, camera compensation dial set at +0.7, 50-speed film, 1/250 second, f/11, handheld.*
BILL LEONARD

It's magical to visit a pond at night during the peak breeding choruses of frogs. You can literally feel the waves of sounds pulsing across the water. Amid the din, you become keenly aware that you're merely a visitor to their watery world.

Bill enjoys taking people into the marshes at night to share the experience. Adults and even "hardened" teenagers change into inquisitive children as the frogs continue their performance spotlit in the beam of a flashlight. The sights of fully inflated, singing males, mating pairs, and females along the pond edge are miracles of nature. More than one child has recalled an evening at the pond as a high point of his or her life.

Pacific treefrogs are among the most colorful and polymorphic species of frogs in the American West. Bill found this beautiful female one February night at the edge of the breeding pond. Several minutes after this photograph was taken, she swam into the pond, where she was met and amplexed almost immediately by a calling male.

Female Pacific treefrog *(Hyla regilla)* entering a breeding pond. *105mm macro lens with electronic flash, camera compensation dial set at +0.7, 50-speed film, 1/250 second, f/11, handheld.*
BILL LEONARD

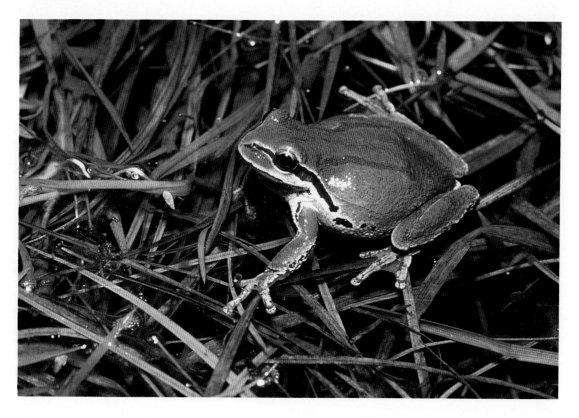

A handheld, close-up flash rig allowed Bill to maneuver into position beneath this lizard's desert perch and use the blue sky as a backdrop.

Mojave black-collared lizards are intelligent, observant animals. When around them, you get the feeling that you're as much of a curiosity to them as they are to you. While photographing this male, Bill paused to reach into his camera bag for another roll of film. Suddenly, the lizard took great interest, jumped down, and climbed into the camera bag for a closer inspection of its contents. Afterward, it returned to its perch, the better to observe this odd desert visitor.

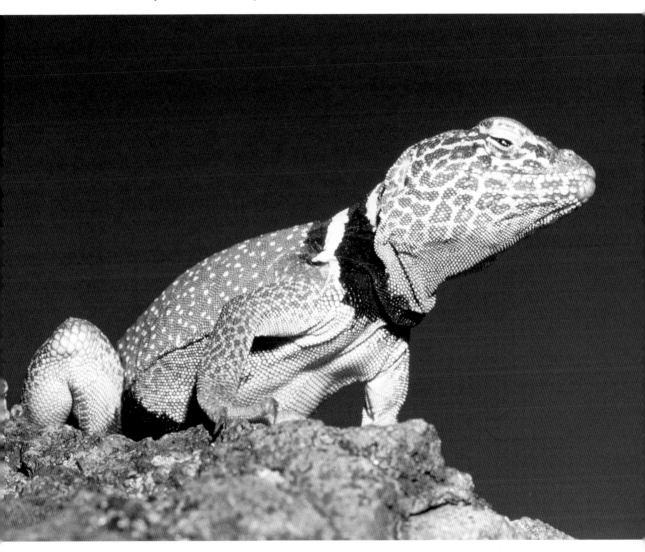

Mojave black-collared lizard *(Crotaphytus bicinctores)* basking on a boulder. *200mm macro lens with electronic flash, camera compensation dial set at +0.3, 50-speed film, 1/250 second, f/11, handheld.* BILL LEONARD

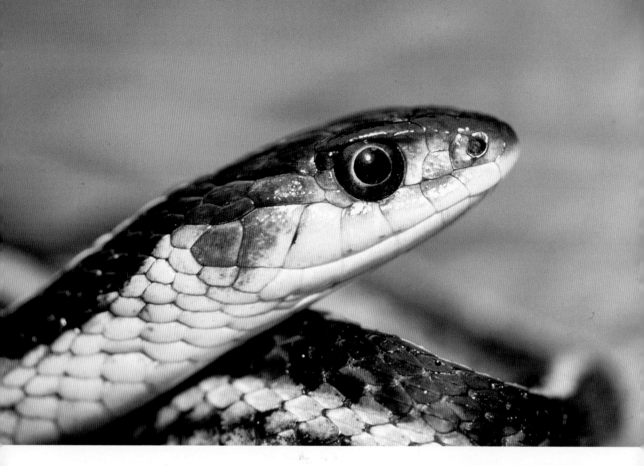

Valley garter snake *(Thamnophis sirtalis fitchi). 200mm macro lens with 3T close-up lens, electronic flash, camera compensation dial set at +0.3, 50-speed film, 1/60 second, f/16, handheld.*
BILL LEONARD

Valley garter snakes are commonly found around wetlands and other aquatic habitats as they hunt for frogs and salamanders. This handheld close-up flash rig gave the working distance and magnification needed to make this tight portrait.

The valley garter snake is a common resident of wetlands and riparian areas in much of the Pacific Northwest. When it is fleeing from a predator, the conspicuous stripes create the optical illusion that the snake is barely moving. Anyone who has attempted to grab a moving garter snake only to come up empty-handed can attest to the effectiveness of this defensive coloration.

One of the most interesting times to observe and photograph valley garter snakes is in the early spring, when they first emerge from overwintering dens. The smaller adult males emerge first and congregate around the entrance, basking and waiting for a female to exit the den. When a female appears, she is immediately greeted by several males, who begin courting her by crawling along her side and rubbing her back with their chins. This can lead to the formation of a "mating ball" involving 20 or more individuals.

Unlike most other lizards in the Pacific Northwest, northern alligator lizards are ovoviviparous, giving birth to fully developed young. This adaptation allows the mother to move her young to sunny locales and thus place them in the best available temperatures for development. Apparently, this is a significant advantage in the Northwest's cool maritime climate, where egg-laying reptiles are quite restricted in range. Notice the seed ticks attached to the side of this lizard's head.

Shasta alligator lizard *(Elgaria coerulea shastensis)*. *200mm macro lens, 3T close-up lens, TTL flash, camera compensation dial set at +0.7, 100-speed film, 1/250 second, f/16, handheld.*
BILL LEONARD

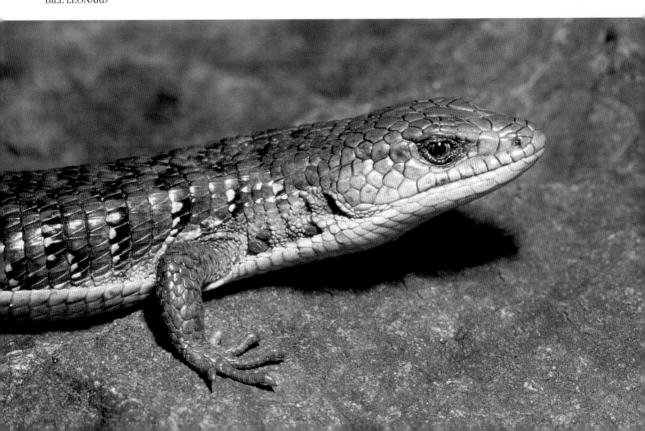

Arboreal salamanders are fascinating animals in many respects. Equipped with prehensile tails, they are expert tree climbers. They are in the group of salamanders known as the "lungless" salamanders (family Plethodontidae), whose members "breathe" by means of gaseous exchange through their moist skin.

Unlike many other salamanders and most frogs, arboreal salamanders lack a free-swimming larval stage. Females deposit their eggs either in trees or beneath bark or rocks on the ground. One or both parents may remain with the eggs during development, guarding them from potential predators and periodically moistening them with skin secretions, which may have antibiotic properties that prevent spoilage. This individual was found and photographed in a mossy rock outcrop in northern California. Fill flash was used to put a highlight in the eye and make the skin glisten.

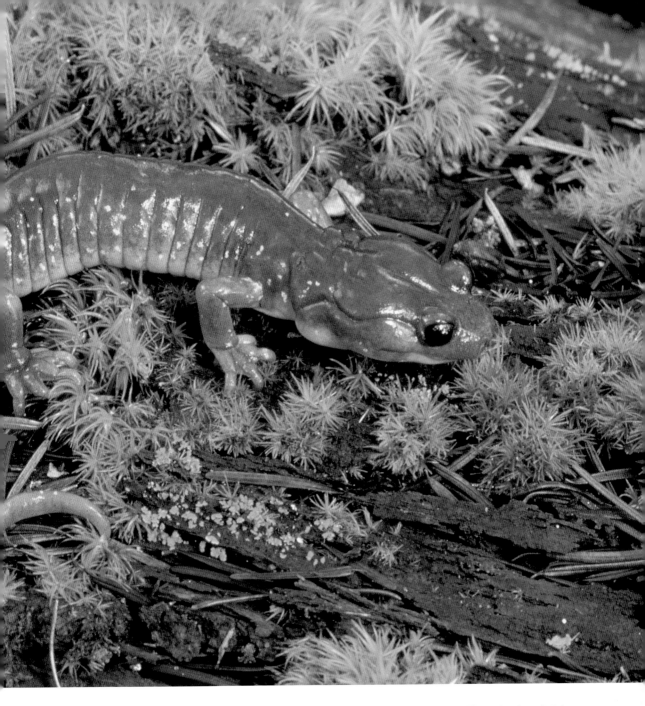

Arboreal salamander *(Aneides lugubris)*.
105mm macro lens, TTL electronic flash,
50-speed film, 1 second, f/16, on tripod.
BILL LEONARD

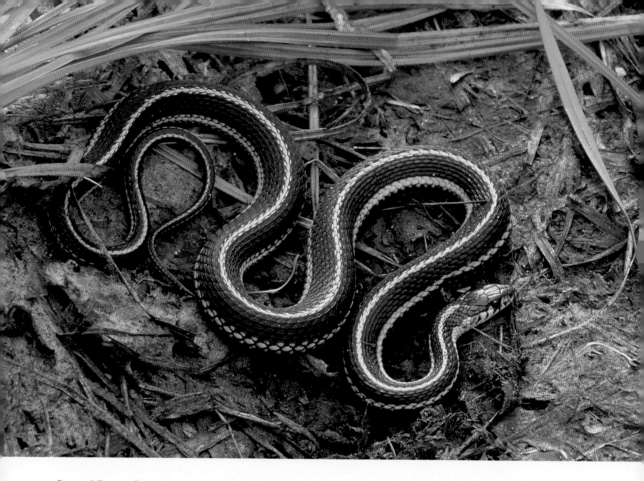

Gravid Puget Sound garter snake *(Thamnophis sirtalis pickeringii)* basking along the edge of a marsh. *200mm macro lens, 50-speed film, 1/30 second, f/16, on tripod.* BILL LEONARD

All garter snakes give birth to live young, which allows them to live in cool, northerly, high-elevation habitats, where most egg-laying reptiles cannot cope. Female common garter snakes are commonly found in grassy meadows near shrubs or blackberry patches. These areas provide females with opportunities for the basking needed to "incubate" the developing young within them. At the first hint of danger, they quickly crawl into the cover of the bushes.

Common garter snakes rely on amphibians as their primary food source and can be found along streams and wetlands where frogs and salamanders are abundant. In some parts of the western United States, introduced trout have eliminated native frog populations, and the snakes disappeared as well—apparently unable to survive on other prey alone.

The diversity of garter snakes is hard to fathom. Within western Washington alone, there are three races (or subspecies) of the common garter snake—Puget Sound garter snake, valley garter snake, and red-spotted garter snake—each so different in color and pattern that it could easily be thought to be a different species.

Photographing Reptiles and Amphibians

Finding Subjects

Amphibians and reptiles live in many habitats, including forests, grasslands, wetlands, streams, lakes and ponds, and even some marine environments. At some sites, they can be found in staggering numbers at certain times of the year. But visit those sites at other times, and you'd be hard-pressed to find one. Your opportunities to see and photograph herps increase greatly as you learn when, where, and how to search for them.

The lives of amphibians and reptiles are as diverse as the habitats in which they're found. Excellent field guides and natural history books are available for many regions (some are listed in the back of this book). Many field guides also provide brief descriptions of the habitat and natural history for each species. Familiarizing yourself with the information contained in field guides will help you learn which species are present in a given area and where they're likely to be, and it will assist you with species identification.

Time spent in the field with the animals in their natural habitat provides the greatest rewards. It seems as though some people are lucky when it comes to encountering great photographic opportunities, but we can assure you that such luck is directly proportional to your knowledge of a subject and the amount of time spent in the field. Serendipity happens only if you put yourself in a place where good things can happen—outside, in the field.

You usually don't have to travel far to find herps. Although we live in different parts of the country, we both have ponds and small woodlots near our homes that abound with garter snakes, salamanders, and treefrogs. We've taken some of our best photographs within 30 miles of home.

It is likely that there are bits of wildness near you, too. When you stick close to home, you spend less time traveling and more time in the field. And with repeated visits, you'll become familiar with the rhythms of life there—which is when you'll be able to make your greatest images. These places are the best ones for experimenting and learning.

The lives and activities of amphibians and reptiles follow natural cycles. From these cycles you can build a herpetological calendar. An abbreviated herpetological calendar for the Pacific Northwest, where Bill lives, goes something like this:

January. Long-toed salamander eggs and breeding adults can be photographed at the breeding ponds.

February. Red-legged frogs and northwestern salamanders can be photographed at the breeding ponds.

March. Singing Pacific treefrogs can be photographed in lowland marshes.

April. Western rattlesnakes can be photographed around dens in eastern Washington.

May. Rubber boas, sharp-tailed snakes, western skinks, and southern alligator lizards are active in the Columbia Gorge and east slope of the Cascade Range.

June. Common garter snakes can be photographed around streams and wetlands, and singing Woodhouse's toads can be photographed along backwaters of the Columbia River.

July. Giant salamanders are concentrated in and adjacent to stream edges.

August. Torrent salamanders and tailed frogs are concentrated along mountain streams in Olympic and Cascade Mountains.

September. Adult and newly metamorphosed Woodhouse's toads are active at night along the Columbia River in eastern Washington.

October. With the onset of fall rains, western red-backed salamanders and other woodland salamanders return to the surface along seeps and small streams in the Puget Lowlands.

Habitat of foothill yellow-legged frog. *24mm lens, 81A warming filter, 50-speed film, 1/2 second, f/16, on tripod.*

This river in the foothills of the Cascade Range in Oregon provides excellent habitat for the foothill yellow-legged frog. Sadly, this once common species has declined over much of its range due to habitat destruction resulting from the construction of dams and logging practices.

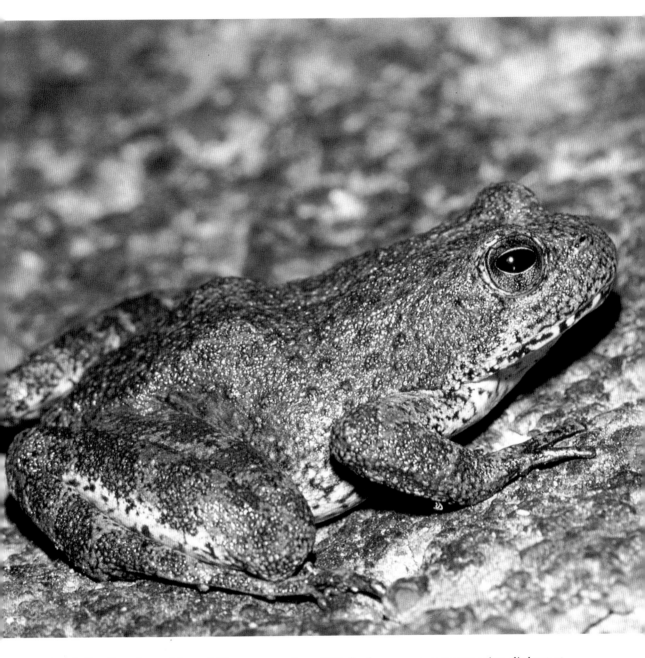

Foothill yellow-legged frog. *105mm macro lens, TTL flash, camera compensation dial set at +0.7, 50-speed film, 1/250 second, f/16, handheld.*

A foothill yellow-legged frog sits on a rock shelf in a scour pool along an Oregon river. The photograph was made from the frog's eye level by placing the camera just above the rock's surface. A handheld flash rig provided a quick way to position the equipment in this difficult situation.

Mountain garter snake *(Thamnophis elegans elegans)* eating an immature bullfrog *(Rana catesbeiana)*. *105mm macro lens, TTL electronic flash, camera compensation dial set at +0.7, 100-speed film, 1/250 second, f/16, handheld.*

Wherever you are, the dramas of the natural world, such as this garter snake eating a bullfrog, play themselves out countless times each day. How often you see them and have an opportunity to photograph them is in direct proportion to the amount of time you spend in the field.

Regardless of where you live, learn to recognize the biological rhythms in your area. This understanding will guide you to the places where you can most readily observe and photograph amphibians and reptiles.

Stalking

Stalking can be the least disruptive method of photographing herps and is usually the most personally rewarding. Without a doubt, some of our most stunning and personally fulfilling photographs of herps were taken while stalking. We would rather have

one excellent photograph of an animal exhibiting its natural behavior than one thousand posed portraits of captive animals. The experience of staying with an animal until it accepts you on its own terms is well worth the time and effort you put into it. Photographs of captive or posed animals can never capture the behavior, magic, and excitement contained in images of unrestrained, free-roaming animals.

Many amphibians and reptiles can be successfully stalked with a little patience and persistence. In fact, some photographs

are nearly impossible to create any other way. Singing frogs at breeding ponds are perfect subjects for stalking. Some species of frogs and toads are difficult enough to find, let alone photograph, during the day. At the breeding ponds after dark, however, the males of many species permit a close approach without any apparent disruption of their activity.

Breeding ponds are easily located in advance with a little field reconnaissance. The loud chorusing of some frogs advertises the pond's location from a considerable distance. Others can be found during the day by looking for egg masses and tadpoles among aquatic vegetation. Preparation is important before entering the pond at night. Hip waders make the experience

Rubber boa *(Charina bottae). 105mm macro lens, TTL electronic flash, flash compensation dial set at -1.7, 50-speed film, 1 second, f/16, on tripod.*

The rubber boa is one of only two species of boas native to North America. As slow and passive as this snake is, it's hard to believe that it could ever catch a small mouse or vole. The short, blunt tail is reportedly used to keep adult mice at bay while raiding young from the nest. A weak fill flash was used to add sparkle to the scales and fill shadows in the dim ambient light.

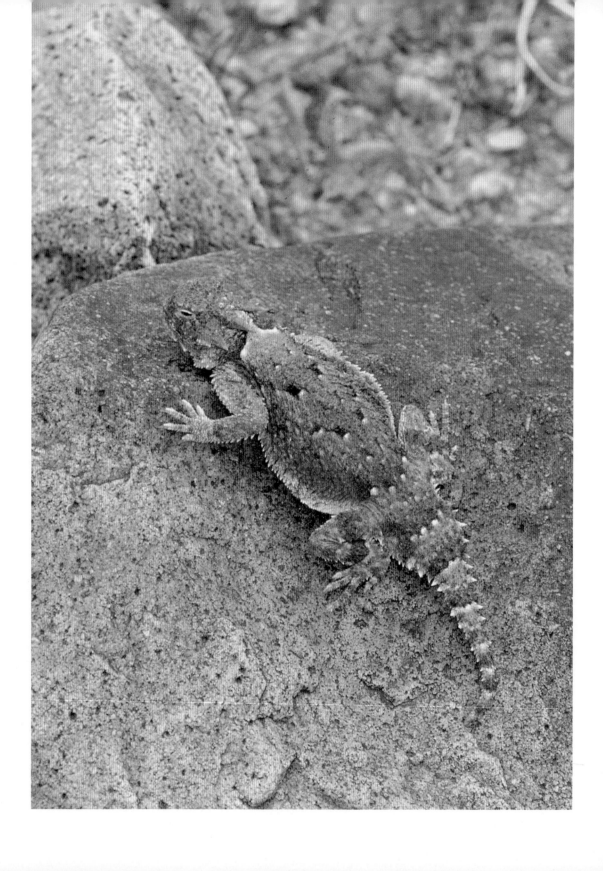

more comfortable, and a good flashlight is essential for getting in and out of the pond as well as for spotting the frogs at the surface of the water. We typically use a lantern with a six-volt battery. It's easier to focus the camera under the beam generated by these larger lights, and the batteries last for nearly a full season of frog watching.

It is safer, helpful, and more enjoyable to work with another person at night in the breeding ponds. Once a singing frog is spotted, one person keeps a beam of light fixed on the frog while the other moves in slowly toward the frog.

How the frogs will behave once they know you're there is impossible to predict. We have gotten completely different results on consecutive nights in the same place. One night, we photographed red-spotted toads (*Bufo punctatus*) in a desert stream in Nevada with amazing success. We were able to work inches away, making many excellent photographs of singing males and breeding pairs before retiring for the night. The next night, we were unable to get a single photograph in the same stream. The toads stopped singing and hopped into shrubs the moment our lights approached. The key is persistence—keep trying.

Many lizards can also be stalked. On a recent trip to the Mojave Desert, we spotted a large chuckwalla (*Sauromalus obesus*) atop a rock outcrop before it quickly slipped into a large crack. Out of excitement and impatience, we tried to tease the animal out, but instead it retreated beneath a

Desert horned lizard (*Phrynosoma platyrhinos*). 200mm macro lens, TTL flash, flash exposure compensation dial set at -1.7, 50-speed film, 1/60 second, f/16, on tripod.

The tripod-mounted camera permitted precise focusing and framing of this basking lizard, and a fill flash was used to reduce harsh shadows.

large boulder. Later, we came upon another individual that behaved the same way, quickly retreating into a rock crevice. This time, however, we stayed back and waited. After a couple of minutes, the animal peeked out at us and was soon back on the rock basking in the sun, where we were able to photograph it at our leisure—and its. The photographs of this animal basking beside its rocky retreat are more meaningful than any we could have taken of a restrained animal.

Photographing Difficult Subjects

Herps often make difficult and uncooperative subjects. Some are secretive, others nocturnal, and others highly mobile, making photography a real challenge. However, as your knowledge of your subject increases, you'll find ways to overcome these challenges. We'd like to share some techniques that we have used to get otherwise difficult photographs.

Teamwork can be an advantage, especially when working with venomous or fast-moving snakes. In this situation, working with another person can make the difference between getting a good photograph and getting none at all. With harmless snakes, we take turns: one person photographs while the other corrals the snake by moving a hand in front of it if it tries to flee. (Gloves are a good idea—even garter snakes can draw blood.)

With venomous snakes, we use a "reptile hook" to gently keep the snake from exiting or, worse yet, advancing toward one of us. By taking turns, both of us are able to take photographs of the animals in their habitats without risk to us or to them. The photographs of the western diamondback rattlesnake were made in this way.

Amphibian larvae—which are usually aquatic, mobile, and well hidden—present a different challenge. We have photographed the larvae of both the tailed frog (*Ascaphus*

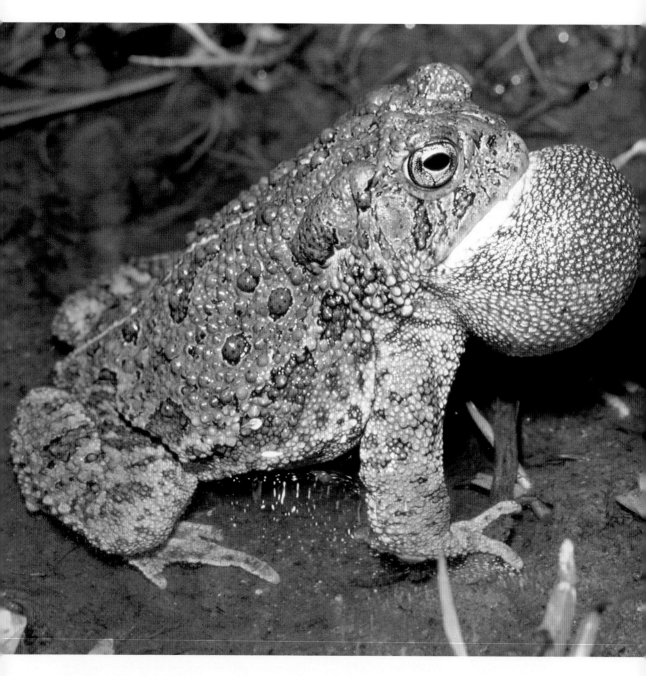

Woodhouse's toad *(Bufo woodhousii). 105mm macro lens, TTL flash, camera compensation dial set at +0.7, 50-speed film, 1/250 second, f/16, handheld.*

Woodhouse's toads are common residents of backwater areas along some sections of the Columbia River in eastern Washington. They are active almost exclusively at night, one of the times when modern TTL full-flash technology is at its best.

truei) and the Pacific giant salamander (*Dicamptodon tenebrosus*) without ever removing them from their natal streams. After locating the larvae, we scoop out a shallow depression in the gravel at the edge of the stream, then gently herd the larvae into these pools. There, we can photograph them in their natural surroundings without any threat to their well-being. The gravel makes an accurate—and aesthetically pleasing—natural background.

Some subjects require more intensive manipulation. Documenting changes in tadpole or salamander larvae development, for example, typically requires setting up a small aquarium in which to rear and photograph them. Small aquariums constructed from plastic or glass can easily be carried into the field. A shallow tray can be constructed from Plexiglas and glued together with silicone, and the bottom can be covered with a shallow layer of stream gravel.

Blanchard's cricket frog *(Acris crepitans blanchardi)* singing. *90mm lens, manual electronic flash, range-finder camera with reflex housing, 10-speed film, 1/60 second, f/11, handheld.*

In the late 1950s and early 1960s, Larry could count on finding cricket frogs in many localities around southern Michigan. Every lake, wetland, and pond had its population of them, and their clicking calls were a common sound on late summer nights. Sadly, Larry hasn't seen one in years. The frog has so declined that it is now considered a species warranting special concern by the Michigan Department of Natural Resources.

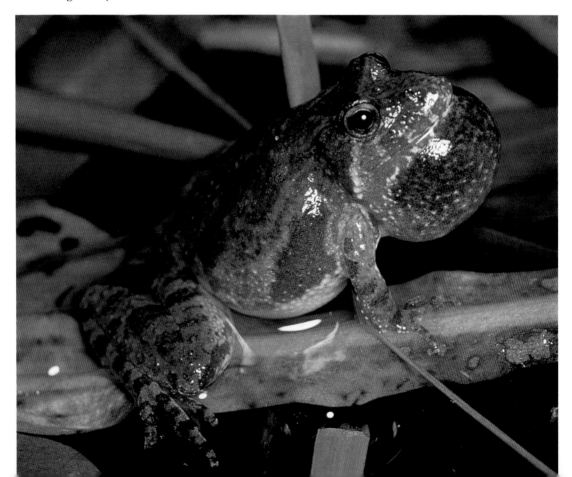

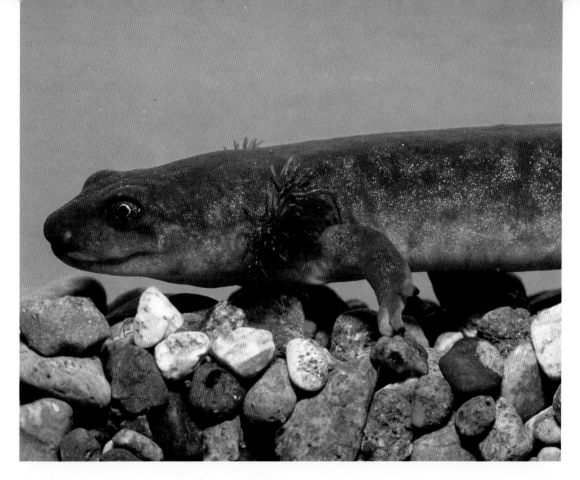

Pacific giant salamander *(Dicamptodon tenebrosus)* larva. *200mm macro lens, 3T close-up lens, TTL electronic flash, camera compensation dial set at +0.7, 50-speed film, 1/250 second, f/22, on tripod.*

This larval giant salamander was photographed in an aquarium with the flash held at a 70-degree angle above the lens to avoid glare. A piece of mat board was leaned against the back of the aquarium to prevent the background from going black.

This setup makes it easy to photograph aquatic larvae from above.

Miniature aquariums built of silicone and single-strength window glass work beautifully for side views of amphibian larvae. Good sizes are 1 by 4 by 6 inches for small larvae and 1.5 by 6 by 8 inches for larger larvae. (The narrow widths keep larvae near the glass, where they're more easily photographed.) Cover the bottom with sand or gravel, fill the aquarium with water, and let it sit at least overnight. This allows bubbles, which would interfere with the photograph, and chlorine from tap water, which could harm the larvae, to dissipate.

TTL flash works to stop any motion of the larvae, but take great care that the glass is completely free of dirt, lint, and fingerprints (fingerprints invisible to the naked eye show up as though the aquarium had been dusted for prints when a flash is used). A photographic gray card or a piece of colored mat board can be propped against the back of the aquarium, thus preventing the background from going black when used with full flash. The camera can be set up on a tripod

to free one hand to hold the flash and the other to work a cable release. The flash should be held above and in front of the lens at about a 60-degree angle. This higher angle reduces problems with reflections off the glass. Any short macro lens will work fine by itself for most amphibian larvae and may be combined with close-up lenses for photographing smaller specimens or for making tight portraits.

If you decide to remove an animal from its environment, it is important that you do so in a responsible manner. The animal's welfare is more important than getting a photograph. Following these simple guidelines will help ensure that this objective is met.

Black salamander *(Aneides flavipunctatus)* guarding her eggs. *105mm macro lens, TTL electronic flash, flash compensation dial set at -1.7, 50-speed film, 2 seconds, f/16, on tripod.*
In this photograph of a captive female black salamander guarding her eggs, fill flash worked its magic—opening up the shadows in the shaded recess behind the eggs and putting a sparkle in her eye.

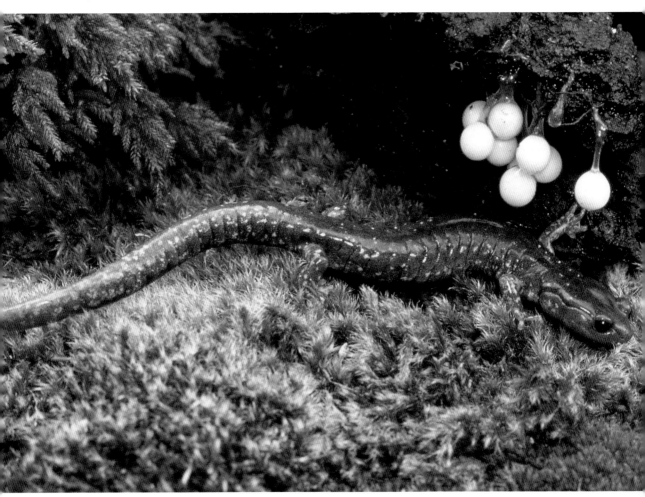

Always:
- Return an animal to exactly the same site from which it was taken.
- Keep an animal for the shortest length of time possible.
- Keep amphibians cool, moist, and out of direct sun.
- Minimize the trampling of vegetation and replace any rocks, logs, and so forth to their original position when conducting searches.
- Be sure to obtain any permits required from the state wildlife agency.

Never:
- Keep animals in overly hot or desiccating conditions.
- Handle herps with mosquito repellent or sunscreen on your hands.
- Harass or abuse detained animals.
- Remove more animals than is necessary.
- Remove animals from their environment without a good reason to do so.
- Search in ways that are destructive to the animals' habitat.

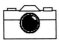

Making a Good Photo Great

Working with Biologists

It is a great privilege to work in the field with someone who has dedicated herself or himself to the conservation of a particular plant, animal, or habitat. We were both fortunate to have such an experience recently when we accompanied Dr. Karin Hoff, a professor at the University of Nevada, to her study area in Nevada to see Amargosa toads.

The Amargosa toad is arguably the most endangered amphibian in North America. Over the past quarter century, the range of the toad has declined dramatically, and it is now restricted to only a handful of sites within its former range. Overgrazing by livestock and wild burros and ill-conceived flood-control projects have combined to destroy much of this toad's habitat in Nevada and California.

During our visit, we accompanied Dr. Hoff to two small desert springs where she is monitoring the remaining populations of toads. Part of her study involves capturing, photographing, and then releasing all adult toads as a way of monitoring the number of individuals in each population. The toads have unique color patterns that enable her to identify individuals and track the general health of the remaining populations over time. Unfortunately, Dr. Hoff's research has led her to the conclusion that the toads are in peril and that immediate actions are needed if the species is to survive.

In the first few hours of searching two springs and sections of the Amargosa River, we saw several thousand tadpoles and one small toadlet. We also learned from Dr. Hoff that this toad has evolved several remarkable adaptations in response to life in the Nevada desert. First, it is highly aquatic, typically remaining submerged in springs or streams during daylight hours, where it is protected from predators and the hot desert sun. Also, during wet springs, this toad may "double clutch," laying multiple sets of eggs and thus taking optimal advantage of good breeding conditions when they are available.

We stayed with Dr. Hoff at a spring until after dark, hoping to see adult toads as they came out to forage for insects. The wait gave us the opportunity to discuss the problems faced by the Amargosa toad and the responsibility humans have to manage the remaining populations. It turns out that even simple measures, such as fencing springs where the toads breed, would help, but these fences have been vandalized. Shortly after sunset, two beautiful adult toads floated to the surface of the desert spring as if by magic. Thanks to the kindness of Dr. Hoff, we got some fine photographs that night, but we left

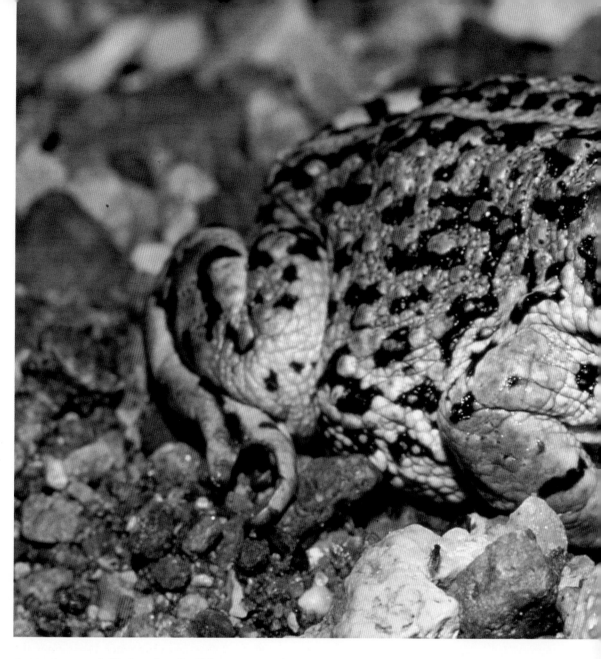

Amargosa toad *(Bufo nelsoni). 105mm macro lens, TTL electronic flash, 100-speed film, 1/250 second, f/11.*

saddened by the knowledge that the existence of this toad is seriously jeopardized by the thoughtless activities of humans.

Some of the most rewarding experiences we have had as nature photographers have come as a result of working with both professional and serious amateur biologists. Working with biologists has provided us with valuable opportunities to grow as both naturalists and photographers. They can teach you how, when, and where to search for amphibians and reptiles, and they can identify and interpret the behaviors and habitat relationships of the species you encounter. They have a lifetime of knowl-

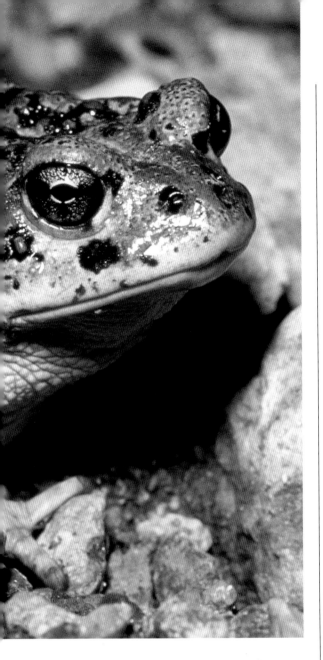

respect the habitats and animals, they'll be more inclined to help again in the future. If you show disregard or lack of concern, it's likely to be the last time you'll work with them. Don't take advantage of their kindness and trust. They have a personal commitment to protecting the animals and their habitats. As nature photographers, we should too.

Framing a Composition

A number of years ago as a self-assignment, Larry photographed in a little meadow near his home every morning for the entire month of September. He would just go there and photograph whatever captured his attention that day, whether it was late-summer flowers, sleeping dragonflies, or drops of dew. He wanted to see if he could get beyond the cliches; if he could create simpler but more sophisticated compositions working with familiar subjects. He wanted to immerse himself in that place.

On one of his excursions, he found a gray treefrog still resting in the cool of the autumn morning. The frog was going nowhere, and the light was nice, so he set up the tripod and framed a number of different compositions.

There are really no hard-and-fast rules for composing a picture, but there are good guidelines to follow. One way to approach composition is in terms of subject: what are you primarily interested in photographing? Think in terms of subject and negative space—the areas around the subject. How you use these components determines the effect a composition will have on a viewer.

Larry likes to create images that are not only informative but also aesthetically pleasing. He wants the lines within the picture to lead the viewer's eye through the composition. He tries to simplify compositions by avoiding extraneous details. He watches the edges of the frame for unwanted blades of grass, branches, or distracting shapes that might protrude into them. He tries to make

edge about these animals that they are often willing to share.

Be observant, and learn as much as you can. But don't misuse these opportunities. Remember, you're asking these people to entrust you with knowledge that they have gained over a lifetime. Your reputation will follow you in the future. If you leave biologists with a positive view of your attitude, showing them that you care about and

111

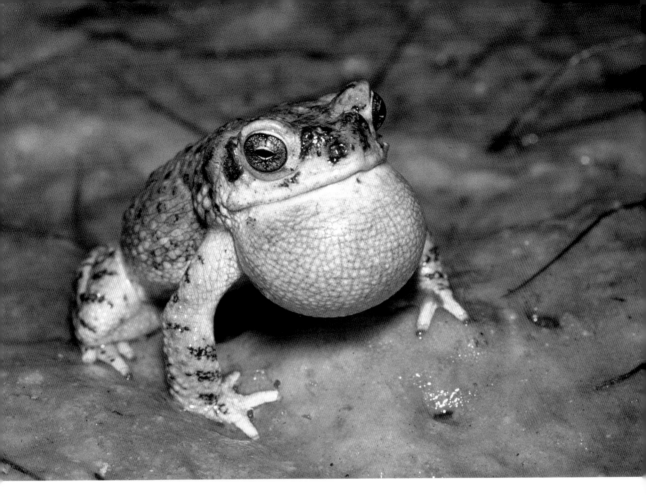

Red-spotted toad *(Bufo punctatus)*, trilling. *Larry West, 105mm lens with 27mm extension tube, handheld with electronic flash, camera compensation dial set at +0.3, 50-speed film, 1/250 second, f/16.*

Gray treefrog *(Hyla versicolor). Larry West, 200mm macro lens, 100-speed film, 1/2 second, f/11, on tripod.*

his compositions look deliberate and well defined so that it doesn't seem like he overlooked something while composing them. He wants viewers to recognize that what they see is exactly what he saw.

It's good to place the subject against the negative space in such a way that the movement of the picture works to your advantage. For example, if you have a lizard looking to the right, you'll probably want to place some negative space to the right, so that its eyes have somewhere to look. The negative space gives direction and the possibility of movement to the photograph

It's generally good to place the subject off center in the frame. Images with the subject dead center and the negative space split equally to the left and the right often seem static. You can add visual dynamics to your photographs by moving your subject up or down, left or right, in the frame.

The old "rule of thirds" works wonders. Imagine a tic-tac-toe grid drawn across the frame. The points where the grid lines cross hold power. Placing your subject on one of these intersections can give it room for movement within the frame and provide a more harmonious arrangement of subject and negative space.

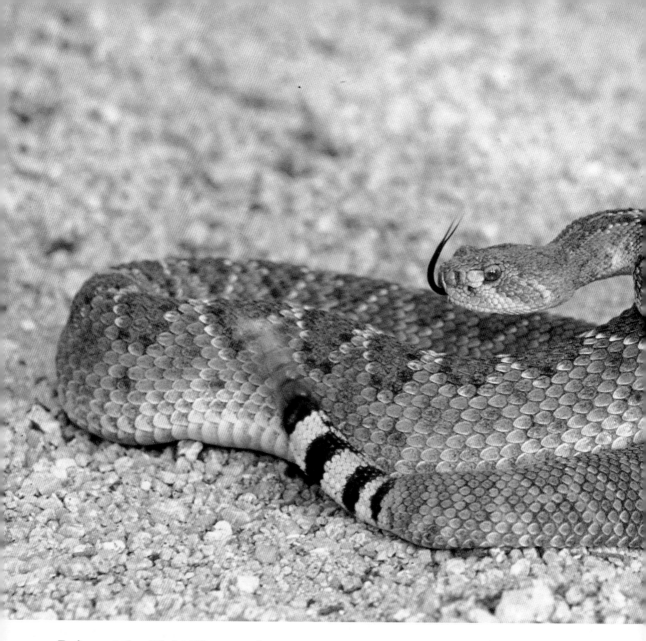

Being at the Right Place at the Right Time

Near the end of a day spent herping in the desert near Las Vegas, we stopped along a stream where we'd seen tadpoles of red-spotted toads. We were both eager to see the adults and decided to wait at the stream until evening to see if they would show up to breed. As twilight fell, clear, musical trills began to rise from along the edge of the stream.

As more toads left their daytime hiding places and entered the stream, we were eventually able to find our first adult. But we discovered that there was no way to get it to pose; it simply wouldn't stay still. It became clear that the only way to photograph them would be to find one that had already staked out a station at the edge of the stream, then carefully move in without disturbing it.

Having finally found a cooperative toad, Larry was half kneeling, half lying in the

Western diamondback rattlesnake *(Crotalus atrox)*, ready to strike. *Bill Leonard, 200mm macro lens, 1.4X multiplier, 100-speed film, 1/30 second, f/16, on tripod.*

toads, they were so wary that they would not allow us to get close. Neither of us got a picture that evening.

The experience reinforced the most basic rule of field photography: you have to be out there in the field to make photographs. The more time you spend in the field, the better and more interesting the images you'll get. Some situations are magical; most are ordinary. The trick is to put yourself in places, and at times, where magic can happen.

So many times we go out with some goal in mind, such as to photograph singing frogs at night, and come away empty-handed. The really great times—photographically—are few and far between. But whether we get the images we seek or not, time in the field almost always offers some reward. And really, just being out—looking, learning, seeing—is reward enough.

Respecting Your Subject

A couple of years ago, we went on a field trip to the Nevada desert to photograph some of the larger lizards and rare desert toads. But right at the top of our wish list for the trip were rattlesnakes. Larry comes from a state with only one species of venomous snake, the shy and seldom-encountered eastern massasauga.

Because of his limited contact with venomous snakes, Larry stays alert and cautious in areas where they're found. As a result, Larry found every rattlesnake we encountered on the trip, including this large western diamondback crossing a wash late one afternoon.

Both of us have tremendous respect for all herps, and especially for rattlesnakes. Cavalier behavior on our part could create a life-

shallow stream, stretched out between several rocks. As he was framing a composition, he suddenly realized that the toad was singing. He was able to get a half dozen frames, and for the next two hours, we were able to record singing males and pairs in amplexus.

We had such an enjoyable time that we decided to repeat the experience. The next night, we drove all the way out and hiked back to the stream. But although we saw

threatening situation or, at the very least, ruin an otherwise pleasant day. And—no less important in our minds—any careless behavior by us could bring harm to the snake.

Consequently, we tend to err on the side of caution when working in venomous snake country. Each of us carries a good snake stick—not to capture specimens, but to protect ourselves in the event of a closer-than-comfortable encounter.

We try to exercise good common sense. Because of Bill's greater experience in working with venomous reptiles, he used his snake stick to stroke the snake's back until it coiled. Then we took turns, one of us photographing while the other kept an eye on the snake. We used long macro lenses, which let us work from well outside the snake's strike zone.

For this image, Bill worked with the camera low to the ground while Larry walked slowly around the snake to draw its attention. At the end of our photo session, the snake went its way, and we went ours.

RESOURCES

Magazines

Nature Photographer
P.O. Box 2037
West Palm Beach, FL 33402
407-586-7332

Outdoor Photographer
12121 Wilshire Boulevard, Suite 1220
Los Angeles, CA 90025-1175
310-820-1550

Reptiles
P.O. Box 6050
Mission Viejo, CA 92690

Reptile and Amphibian Magazine
RD3, Box 3709-A
Pottsville, PA 17901

Herpetology References

Arnold, E. N., and J. A. Burton. 1978. *A Field Guide to the Amphibians and Reptiles of Britain and Europe*. London: Collins.

Bartlett, R. D. 1988. *In Search of Reptiles and Amphibians*. New York: E. J. Brill.

Conant, R., and J. T. Collins. 1991. *A Field Guide to Reptiles and Amphibians of Eastern and Central North America*. Boston: Houghton Mifflin.

Duellman, W. E., and L. Trueb. 1986. *Biology of Amphibians*. New York: McGraw-Hill.

Ernst, C. H., and R. W. Barbour. 1989. *Snakes of Eastern North America*. Fairfax, VA: George Mason University Press.

Ernst, C. H., J. E. Lovich, and R. W. Barbour. 1994. *Turtles of the United States and Canada*. Washington, DC: Smithsonian Institution Press.

Halliday, T., and K. Adler. 1986. *The Encyclopedia of Reptiles and Amphibians*. New York: Facts on File.

Petranka, J. 1997. *Salamanders of the United States and Canada*. Washington, DC: Smithsonian Institution Press.

Rossman, D. A., N. B. Ford, and R. A. Siegel. 1996. *The Garter Snakes: Evolution and Ecology*. Norman: University of Oklahoma Press.

Stebbins, R. C. 1985. *A Field Guide to Western Reptiles and Amphibians*. Boston: Houghton Mifflin.

Stebbins, R. C., and N. W. Cohen. 1995. *A Natural History of Amphibians*. Princeton, NJ: Princeton University Press.

117

Photography References

Lepp, George D. 1993. *Beyond the Basics*. Los Osos, CA: Lepp and Associates.

West, Larry, and Julie Ridl. 1993. *How to Photograph Birds*. Mechanicsburg, PA: Stackpole Books.

West, Larry, with Julie Ridl. 1994. *How to Photograph Insects and Spiders*. Mechanicsburg, PA: Stackpole Books.

Herpetological Journals

Copeia. Published quarterly by the American Society of Ichthyologists and Herpetologists.

Herpetologica and *Herpetological Monographs*. Published quarterly by The Herpetologists' League, Inc.

Herpetological Review and *Journal of Herpetology*. Published quarterly by the Society for the Study of Amphibians and Reptiles. Membership also includes subscription to the quarterly journal.

Refer to library reference desk for current mailing addresses.

Recordings

Frog and Toad Calls of the Pacific Coast. Produced by Carlos Davidson. Library of Natural Sounds, Cornell Laboratory of Ornithology, Ithaca, NY.

Frog and Toad Calls of the Rocky Mountains. Produced by Carlos Davidson. Library of Natural Sounds, Cornell Laboratory of Ornithology, Ithaca, NY.

Voices of the Night, The Calls of the Frogs and Toads of Eastern North America. Library of Natural Sounds, Cornell Library of Ornithology, Ithaca, NY.

Nature Photography Equipment

Century Precision Optics
10713 Burbank Boulevard
North Hollywood, CA 91601
800-228-1254

Kirk Enterprises
RR #4 Box 158
Angola, IN 46703
219-665-3670

Leonard Rue Enterprises
138 Millbrook Road
Blairstown, NJ 07852